THE WHITE PASS AND YUKON ROUTE RAILWAY

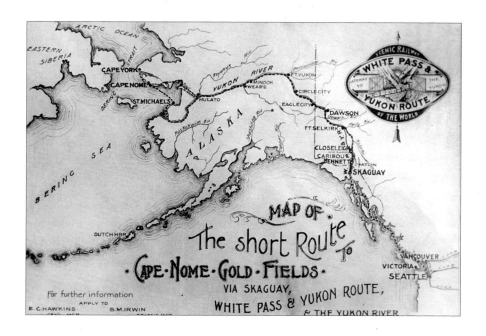

Graham Wilson

D0973423

Edited by Clélie Rich,
 Rich Words Editing
 Services, Vancouver, B.C.
Imaging by Andrew
 Robulack, Bear
 Communication,
 Whitehorse, Yukon
Design and Production by
 Wolf Creek Books Inc.
Printed and Bound by
 Friesen Printers, Altona,
 Manitoba

**Canadian Cataloguing in
Publication Data**
Wilson, Graham, 1962-
The White Pass and Yukon
Route Railway
(100th anniversary
collection)
Includes index.

ISBN 0-9681955-2-0

1. Railroads--Yukon
Territory--Construction--
History. 2. White Pass &
Yukon Route (Firm)--
History. 3. Railroads,
Narrow-gauge--Yukon
Territory--History. I.
Title. II. Series.

HE2810.W48W54 1998
385'.52'097191
C98-900378-7

This book is the result of the
cooperation and support of
many people. The White Pass
Corporation, especially Tina
Cyr, provided much encour-
agement and assistance
throughout the entire process
of developing this work.
Alice Cyr carefully edited the
text to ensure its historical
accuracy. The author also
wishes to thank Lauren
Crooks and Emily and Jessica
Wilson for their patience and
understanding while this
edition was prepared. John
Small helped define this
project and gave many critical
insights. Ford Colyer from the
Yukon Territorial Archives
prepared many of the
photographs in this book. And
finally, most of the credit for
this book rests with the
photographers, particularly
H.C. Barley, who toiled to
capture this legendary
undertaking.

**WOLF CREEK
BOOKS INC**

BOX 31275, 211 MAIN STREET,
WHITEHORSE, YUKON, Y1A 5P7

CONTENTS

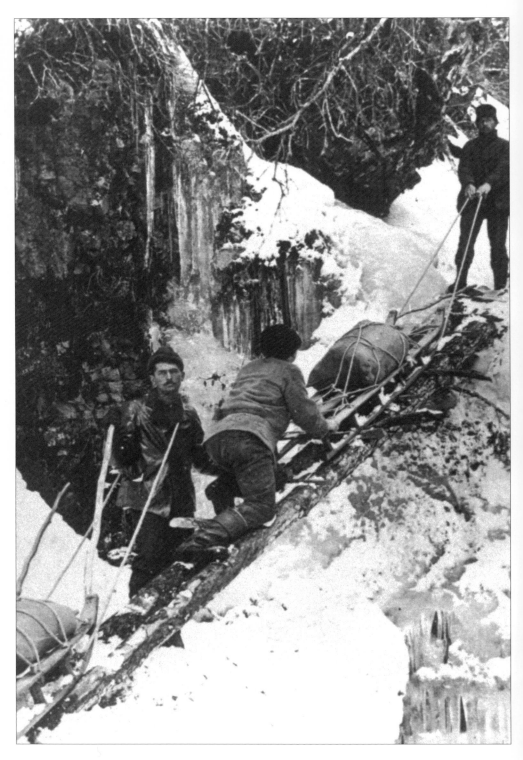

BONANZA!

When the small steamship *Excelsior* docked in San Francisco in July 1897, the world was watching. Aboard this vessel were millionaires who had been penniless men only months before. As these scruffy miners swaggered down the gangplank carrying jars, satchels and cases filled with gold, more than five thousand people crowded the docks and cheered.

A few days later the steamship *Portland* landed at Seattle with sixty-eight miners and almost a ton of gold. The news of the find grabbed newspaper headlines and was on everyone's lips. Overnight, the word *Klondike* took on mythic proportions.

Within days thousands flocked to west coast towns from San Francisco to Vancouver trying to book passage north. The fact that the Klondike was more than fifteen hundred miles away and over a precipitous mountain pass would not deter many. Gold fever had grasped the nation, and everyone wanted the chance to try their luck in the new frontier.

The stampeders faced one of the most arduous treks imaginable. They traveled up the coast in overcrowded and often decrepit ships. They spent the winter ferrying supplies over the cold and dangerous Chilkoot and White Passes, then built rickety boats and navigated the lakes and rapids of the Yukon River.

Most stampeders arrived in Dawson in the spring and summer of 1898. They wandered into this carnival-like town exhausted from their journey. Many stories tell of stampeders who, upon arriving in Dawson, immediately booked passage home, so travel weary and worn-out they did not have any energy to even try to work a claim.

Most of the population of Dawson dined on beans and pancakes. They slept in canvas tents and spent their days in idle anticipation of finding their fortune. They had endured the most difficult experience of their lives

Opposite: Men hauling sleds up "Jacob's Ladder," in a canyon near Sheep Camp, Chilkoot Trail, Alaska.

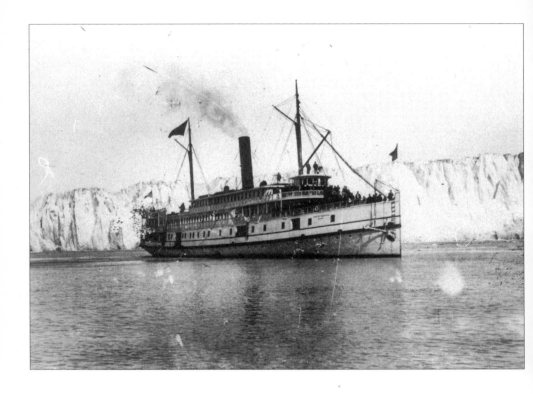

just getting to the Klondike valley. Now they were idle, with little opportunity to stake their own claim or even work someone else's.

Many entrepreneurs took note of the difficulties involved in reaching the goldfields. The largest obstacle was the journey over the coast mountain range. Plans for tramlines, tunnels and hot air balloons were proposed. In the end the proposal of a narrow gauge railway through the White Pass to the headwaters of the Yukon River appeared most feasible. But that did not mean it would be easy to build and maintain a railway through the region. Nevertheless, a railway was born—the most individual railway in the world.

Above: Steamship "City of Seattle" in Glacier Bay, Alaska, with Muir Glacier in the background.

Opposite Top: Stampeders amid mountains of supplies landed near the mouth of the Taiya River near Dyea, Alaska.

Opposite Bottom: Family carrying heavy packs and pulling a handcart at the start of the Chilkoot Trail.

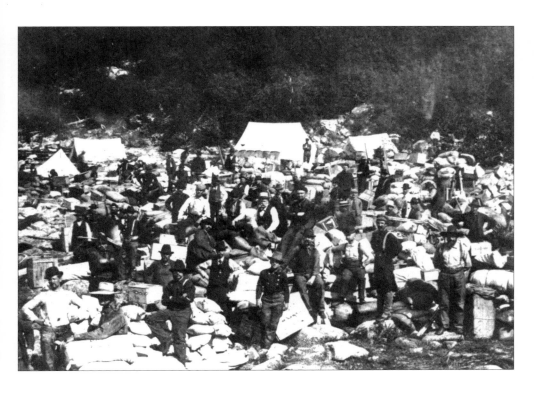

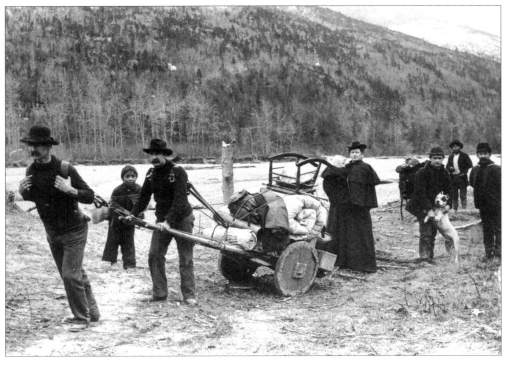

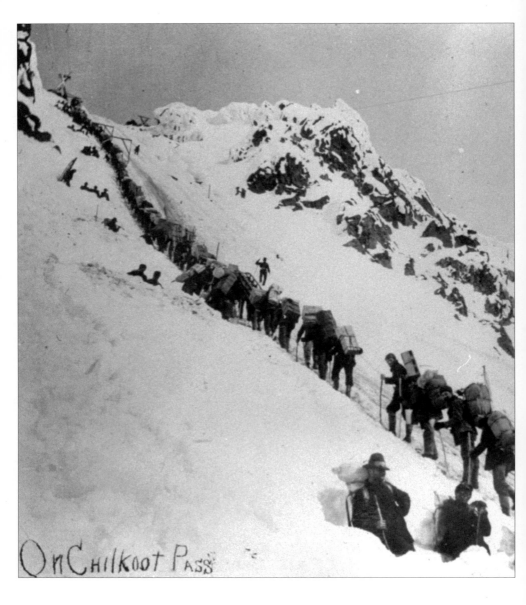

On Chilkoot Pass

It is the inexperience of those who are trying to go over. They come from desks and counters; they have never packed, and are not even accustomed to hard labor.
Tappan Adney, Journalist, 1899

Above and Opposite: Famous photographs of stampeders climbing the "Golden Stair" to the Chilkoot summit.

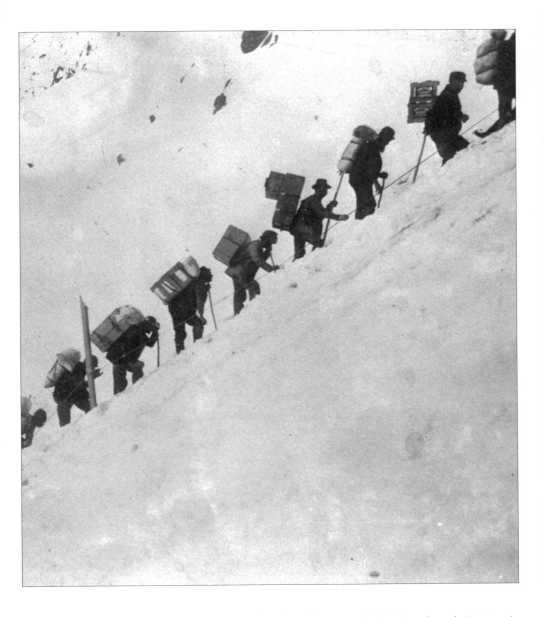

There is nothing but the gray wall of rock and earth. But stop!
Look more closely. The eye catches movement. The mountain is
alive. There is a continuous moving train; they are perceptible
only by their movement, just as ants are. The moving train is
zigzagging across the towering face of the precipice, up, up, into
the sky, even at the very top. See! They are going against the
sky! They are human beings, but never did men look so small.
Tappan Adney, Journalist, 1899

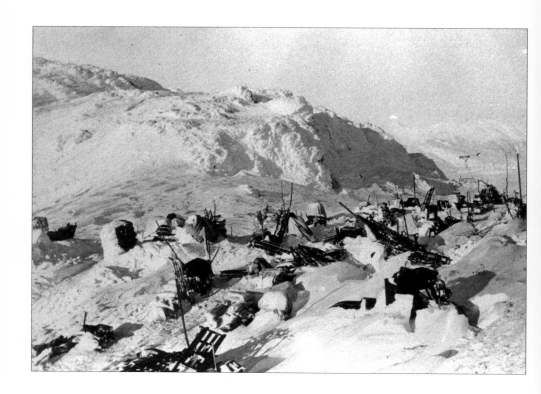

In my memory it will ever remain a hideous nightmare. The trail led through a scrub pine forest where we tripped over bare roots of trees that curled over and around rocks and boulders like great devilfishes. Rocks! Rocks! Rocks! Tearing boots to pieces. Hands bleeding with scratches. I can bear it no longer. In my agony, I beg the men to leave me – to let me lie in my tracks.
Martha Black, 1898

Above: The frozen summit of the Chilkoot cluttered with supplies. Blizzards frequently buried stampeders' caches under several feet of snow overnight.

Opposite: Stampeders running treacherous Miles Canyon on the Yukon River, near Whitehorse.

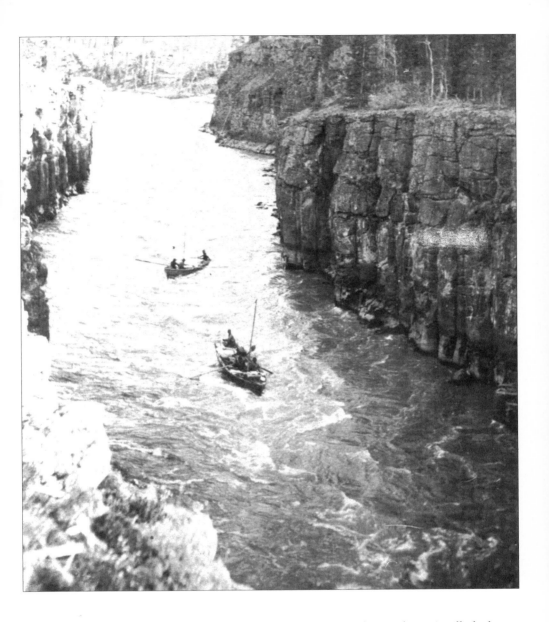

Wild waves rocked and rolled our boat and occasionally broke over us. The spray rose so thick and high we could not see the shore, the very air seeming a sea of misty spray. It was simply glorious. All too soon we rowed into comparatively smooth yet rapid water. A few more strokes of the oars sent us to the shore and the ride was over, leaving a sensation never to be forgotten.
Emma Kelly, 1899

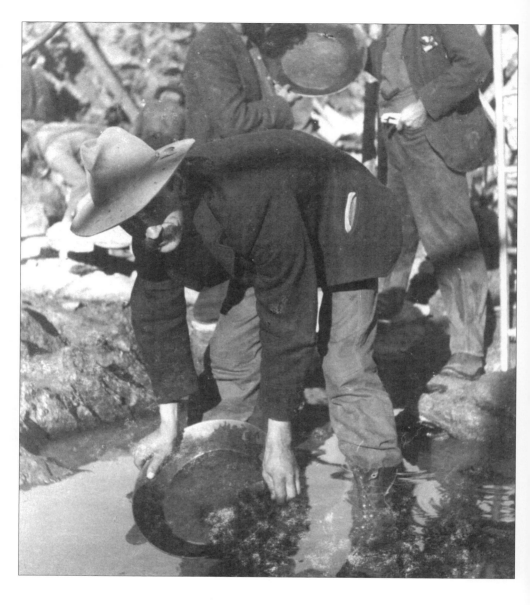

There are many men in Dawson at the present time who feel keenly disappointed. They have come thousands of miles on a perilous trip, risked life, health and property, spent months of the most arduous labor a man can perform, and with expectations raised to the highest pitch, have reached the coveted goal only to discover the fact that there is nothing here for them.
The Klondike Nugget, June 23, 1898

Above: Panning for gold on Bonanza Creek.

Opposite Top: Meals tended to be simple and repetitious for most stampeders.

Opposite Bottom: Interior of a store with a man pouring gold dust from a pouch to be weighed.

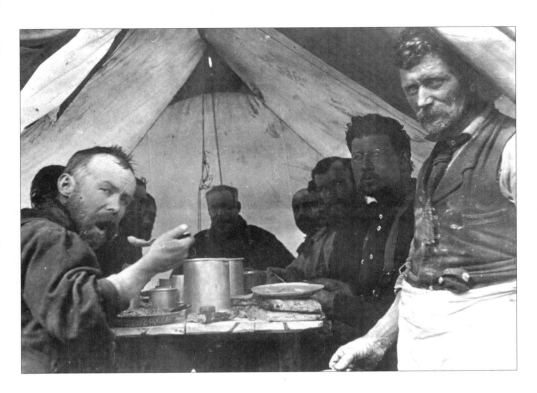

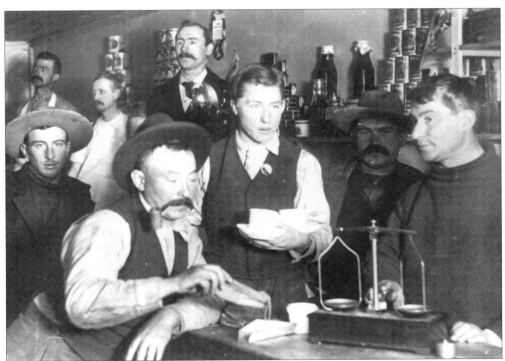

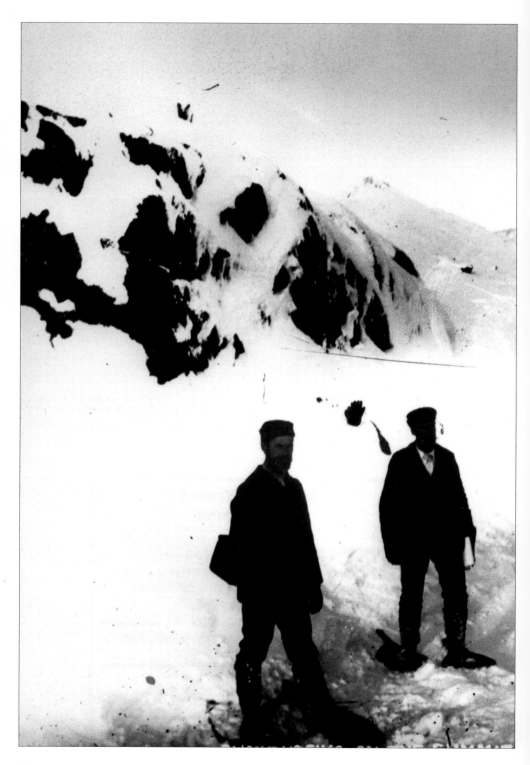

BIRTH OF A RAILWAY

In the early stages of the Klondike Gold Rush, the steep and narrow White Pass Trail was swamped with eager stampeders. As news of the gruesome condition of the trail spread, George Brackett, a former mayor of Minneapolis, made plans for a wagon road. Construction of Brackett's wagon road began in November 1897, and by that December eight miles of the road was complete. Brackett refinanced the venture and construction was finished by March 1898 with a total of 12 miles of wagon road. This toll road was a vast improvement over the horse trail that had caused so much misery and suffering.

Before construction of Brackett's wagon road was complete, Michael Heney had hiked the entire White Pass Trail. Heney was an experienced rail builder from Canada. He felt a railroad could be built through this precipitous mountain pass although it would be a relatively expensive venture. Heney tried to gather support for the railway but his plans received a mixed reception. Most people felt that construction of a railway through this pass was impossible. In addition, railways in North America had a history of being constructed behind schedule and over budget. Raising enough money was difficult.

A chance meeting would ensure the fate of Heney's dream. In April 1898 Heney was having a drink in the St. James Hotel in Skagway, when he met representatives of Close Brothers, an English investment bank. These men had also hiked the White Pass and had concluded that a railway was not feasible. Obstacles such as cutting a grade around Rocky Point or building massive bridges seemed insurmountable to them. But Heney was tenacious, and as the men sipped scotch and smoked Havana cigars, various options were considered. Heney argued that while the railway would be expensive, it held great potential as a transportation

Michael Heney, at left, snowshoeing at the White Pass Summit.

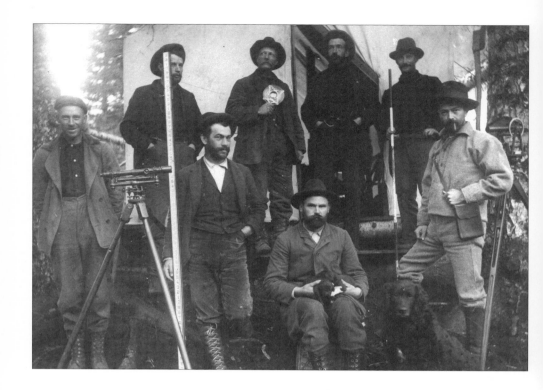

Above: Members of F.B. Flood's Engineering Corps pose with surveying transits and rods in front of their tent. September 1898.

corridor and as a tourist attraction. The financiers quickly realized that if they could raise the estimated construction costs of ten million dollars, Heney could be relied upon to build the railway. By morning a construction plan was roughed out and within weeks the White Pass and Yukon Route Railway Corporation was formed.

The plan was to construct a 110-mile long narrow gauge railway which would connect Skagway, Alaska to Whitehorse, Yukon. Essentially, the railroad would overcome the two main obstacles to reaching the Klondike goldfields; the coastal mountains and the rapids on the Yukon River upstream of Whitehorse. The railway would be narrow gauge since a 36-inch railbed requires less materials, can handle sharper corners and is easier to build. Heney was the construction contractor. Facing many hurdles, he supervised one of the most ambitious railways ever built.

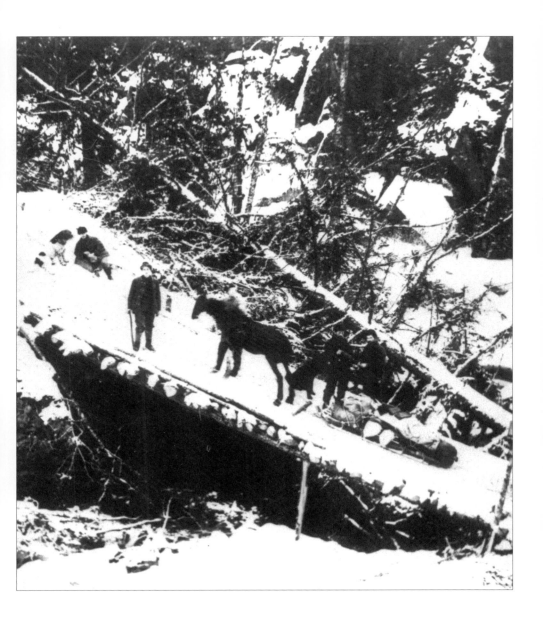

Above: Brackett's Wagon Road was a toll road and was a vast improvement over the former White Pass Trail.

Rain, rain, all the time — no sunshine up in these mountains; tent pitched in a mud-hole, bed made on the stumps of bushes, blankets and everything else wet and muddy.... Even the wood is wet, and will only smoke and smoulder.
Tappan Adney, Journalist, 1899

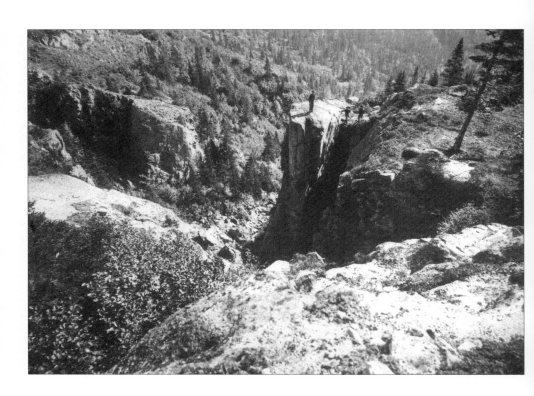

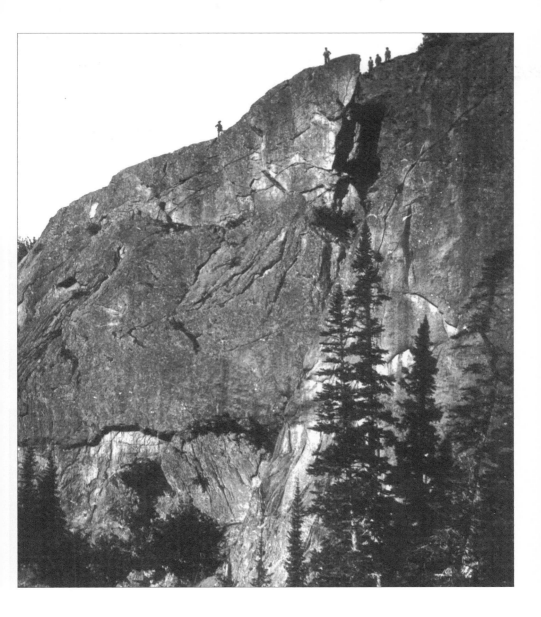

Opposite Top: Three men on the cliff overlooking Glacier Gorge surveying the possible routes for the White Pass and Yukon Route Railway. July 1898.

Opposite Bottom: View of the location stakes for the railway in the dense coastal rain forest of the Skagway valley. September 1898.

Above: View of several men on top of a cliff surveying a possible tunnel site. July 1898.

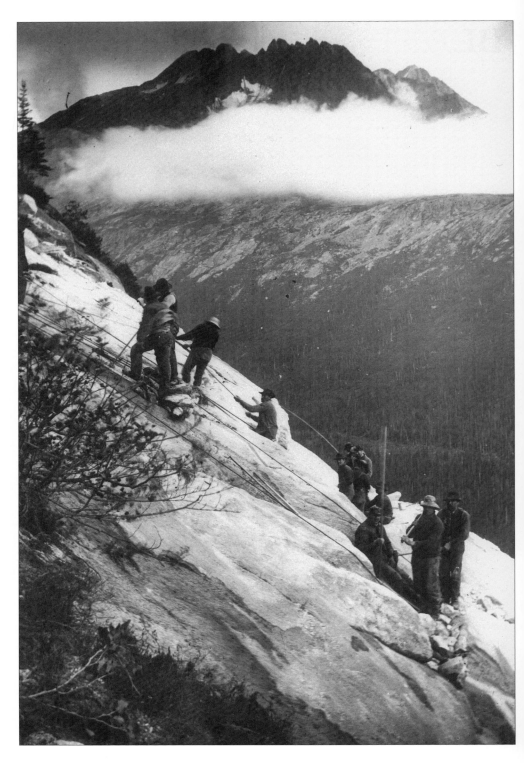

BLASTING A PASS

Construction of the White Pass and Yukon Route Railway began in haste on May 28, 1898. The large number of idle stampeders in Skagway and Dyea, Alaska provided an eager workforce. Laborers were paid three dollars a day, and with overtime some earned more than a hundred dollars a month. To augment this able workforce, tradespeople were recruited from outside Alaska. The first crews surveyed the Pass and determined where the track would be laid. Next, timber cutters cleared a passage. As many as 2,000 laborers at any one time hacked and blasted the route for the rail bed. Carpenters, engineers and welders constructed tunnels and enormous bridges through this epic landscape.

The steep granite mountain sides were perhaps the greatest obstacle to construction. Holes were pounded into the rock using "two-man jacks" and packed with explosives. In total 450 tons of black powder and dynamite were used to blast a path to the summit. Entire mountain sides were shattered, and valleys echoed with the thunder of black powder. Men dangled a thousand or more feet above the ground on hemp ropes and wrestled with pry bars to dislodge the remaining rock. Horses far below hauled sled loads of boulders and debris off the rail bed. Ties were imported from Oregon to be laid and spiked. More than three thousand ties were required to gain each single mile of railway.

In addition to blasting through the Pass, enormous bridges and tunnels had to be built. The most impressive was the steel cantilever bridge which spanned a wide canyon and was the tallest in the world when it was built. The White Pass and Yukon Route Railway earned the distinction of being declared an International Historic Civil Engineering Landmark.

Crews came and went, and it is estimated that, all told, more than 35,000 men worked on building the White Pass and Yukon Route Railway. But the

Close-up view of railway workers using ropes to support themselves on the steep face of Tunnel Mountain. September 1898.

stampeders had not traveled thousands of miles to work as laborers on a railway. Rumors of gold strikes would empty a camp in minutes. On August 8, 1898 the word of a strike in Atlin, BC resulted in 700 workers walking away from their jobs and rushing inland.

Construction of this railway was dangerous work although less than 35 fatalities were recorded, which was considered a low death toll. Fortunately accidents, such as the one on August 3, 1898 when a 100-ton boulder slid onto two laborers, were rare. Most fatalities were from diseases such as pneumonia and meningitis.

As the first summer of construction wore on, men worked in shifts around the clock. The midnight sun held advantages for the most northerly railway in North America. On July 21, 1898 the first excursion train reached Rocky Point, about seven miles from Skagway. The rail continued to climb towards the White Pass summit of 2,865 feet. The rail gains this altitude over about 20 miles and has an average grade of 2.6% although in places it is almost as steep as 4%. The White Pass and Yukon Route Railway is one of the steepest in the world.

As winter came, the ravages of the cold and snow took their toll. Crews worked in numbing one-hour shifts throughout the winter and production slowed to a snail's pace. Snow drifts of 35 feet buried track, and temperatures of -65 degrees hampered progress. Nevertheless, on February 20, 1899, the first locomotive clambered to the White Pass summit and history was made. The railway was far from complete but the largest obstacle was now behind it. As dignitaries, investors and crew alike toasted their accomplishment, Michael Heney, "the Irish Prince," was busily planning his way to Bennett and beyond.

Opposite Top: Work crew cutting brush from a hillside on the railway grade. August 1898.

Opposite Bottom: Wood cutter with axe standing next to his log-laden jackass. September 1898.

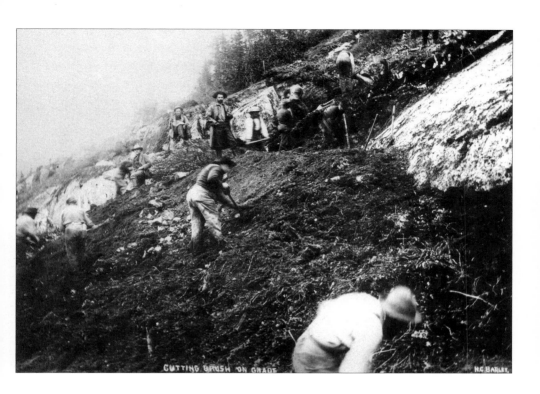

CUTTING BRUSH ON GRADE H.C.BARLEY.

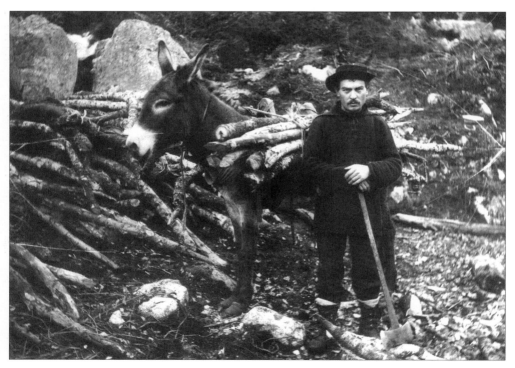

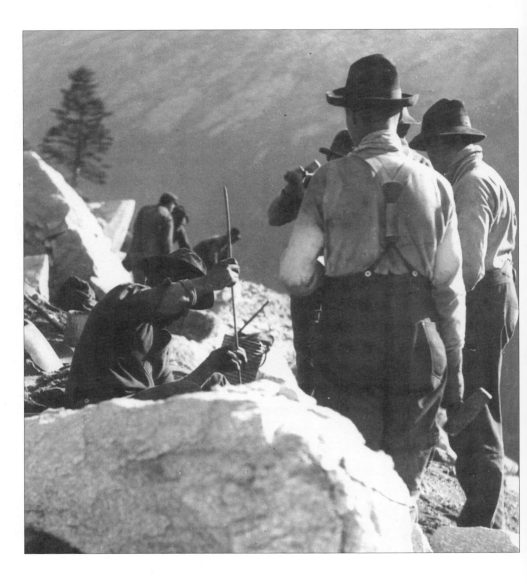

This great piece of work has been accomplished without a dollar's aid from any government or any concession except the right-of-way, which had no possible value without the railway. It is no disparagement to other mountain railways to say that the construction of the White Pass & Yukon is among the most brilliant feats of railway engineering, in view of the tremendous difficulties to be encountered and the shortness of the time in which the work was done.
Victoria Colonist, December 1900

Above: Workers putting in a blasting charge.

Opposite: A long line of workers carrying blasting supplies as they climb up a chimney-like structure in the rock face at Summit Cliff in order to place a blasting charge. September 1898.

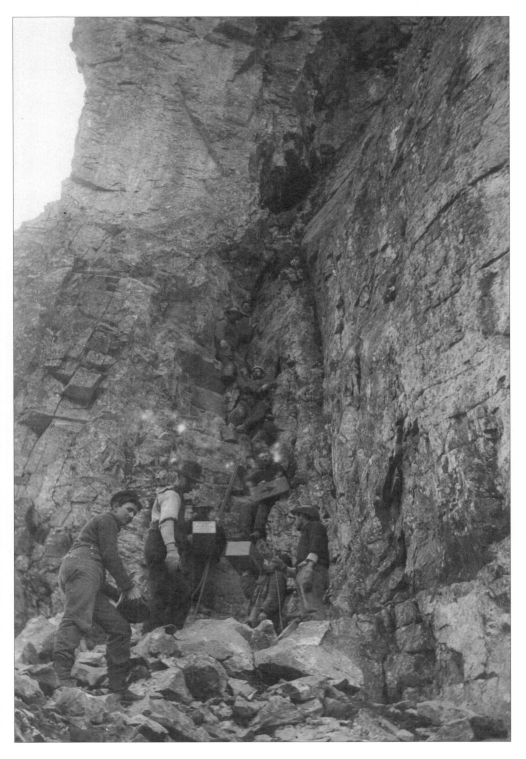

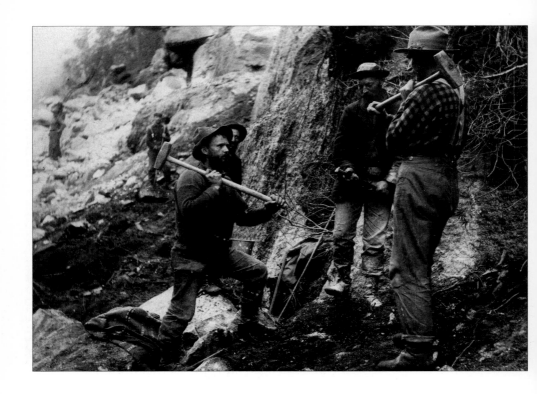

A blast which would put to shame the eruption of Mount Vesuvius was successfully touched off on the railroad last Saturday evening. It was at the big gorge next to the tunnel above Camp 9, high upon the mountain side overlooking White Pass City. The monster charge of 2700 pounds of dynamite was exploded at once. No one can accurately compute the enormous amount of rock which the explosion displaced. One eye witness declared that the rock was blown away from the side of the mountain for a half mile high, but that is doubtless an exaggeration. However, it was a blast which will never be forgotten by those who saw it or equaled again in all probability in Alaska.

The Daily Alaskan, January 16, 1899

Above: A work crew using a "two-man jack" which is a sledgehammer and spike. The person holding the spike turns it after each blow. Once a hole is drilled, it is packed with black powder and detonated.

Opposite Top: A cloud of dust from a blast appears in the background of the railway grade.

Opposite Bottom: Laborers using wheelbarrows to remove rock from the end of the railway grade near the White Pass summit. August 1898.

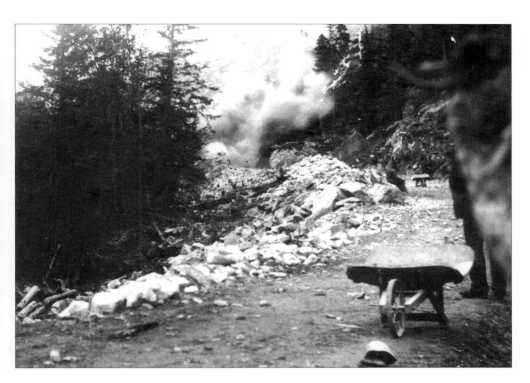

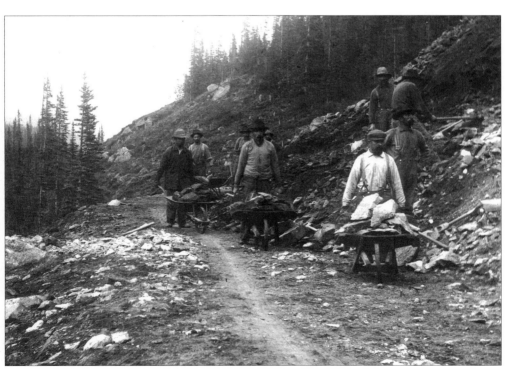

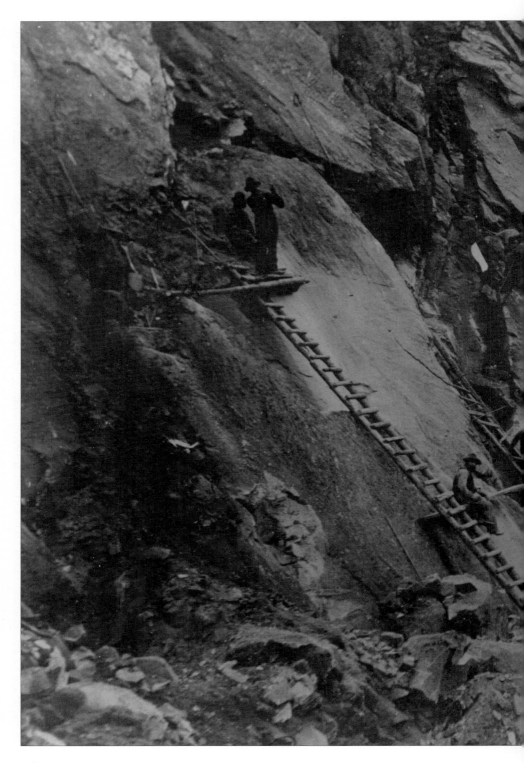

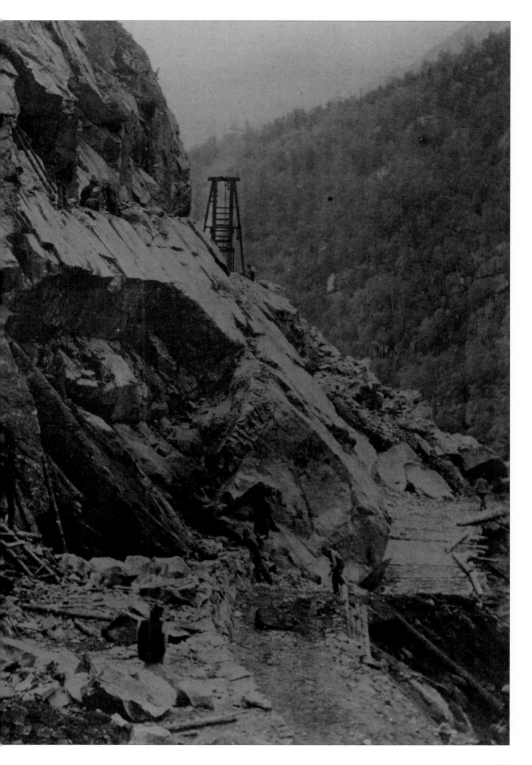

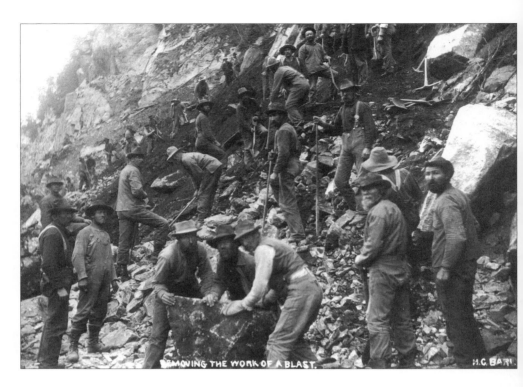

REMOVING THE WORK OF A BLAST.

H.C. BARI.

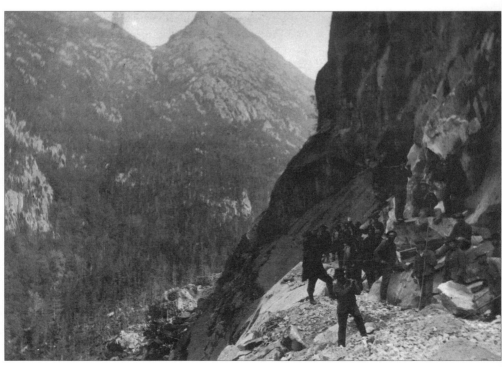

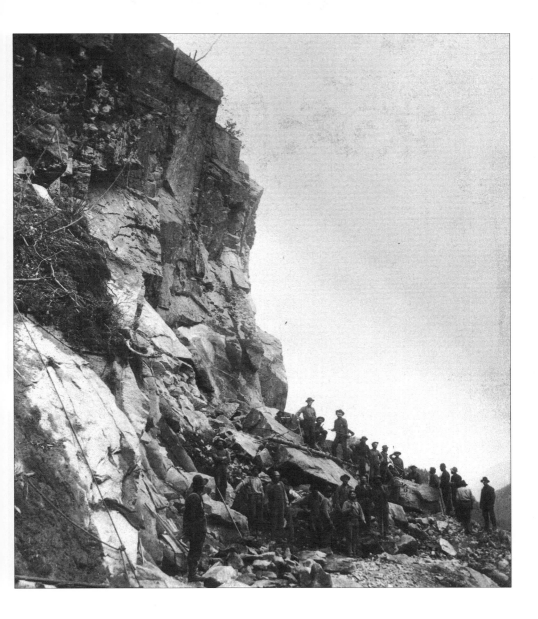

Pages 28 and 29: Crews worked around the clock during the spring and summer to complete the railroad.

Opposite Top: A large group of workers remove rock and rubble caused by a blast from the railway grade. September 1898.

Opposite Bottom: On the side of Porcupine Hill a work crew removes debris displaced by black powder and pry bars. Below can be seen the White Pass Trail, and through the trees a glimpse of Brackett's Wagon Road. August 1898.

Above: Laborers standing on a flat section below a vertical cliff where they have been clearing boulders to make a grade for railway tracks. August 1898.

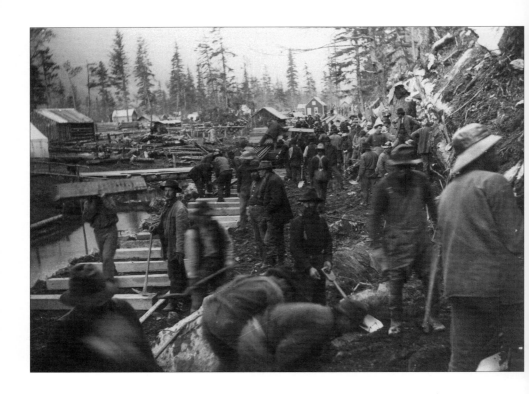

As a result of the mass meeting held, Tuesday night, the Skagway & White Pass Railroad Co. was, by the city council, granted a right of way over the thoroughfare known as Broadway, and at seven o'clock, Wednesday morning, upwards of 500 men were working like beavers, excavating, grading and leveling a road bed in the middle of the highway. By ten o'clock in the forenoon the grade had been completed and ties were being laid. Two hours later these ties were being bound together by steel rails, and when the sun set Wednesday evening, upwards of a mile of railroad had been graded, tied and railed, and was ready for the locomotives, the work having all been done in the short space of thirteen hours.
Skagway News, June 17, 1898

Above: Work crews laying railway tracks along the bluff at the north end of Skagway. In the background are the tents and cabins of the community. September 1898.

Opposite: A group of bridge carpenters sitting down to their lunch at a makeshift table. In the background is a railway trestle and tunnel.

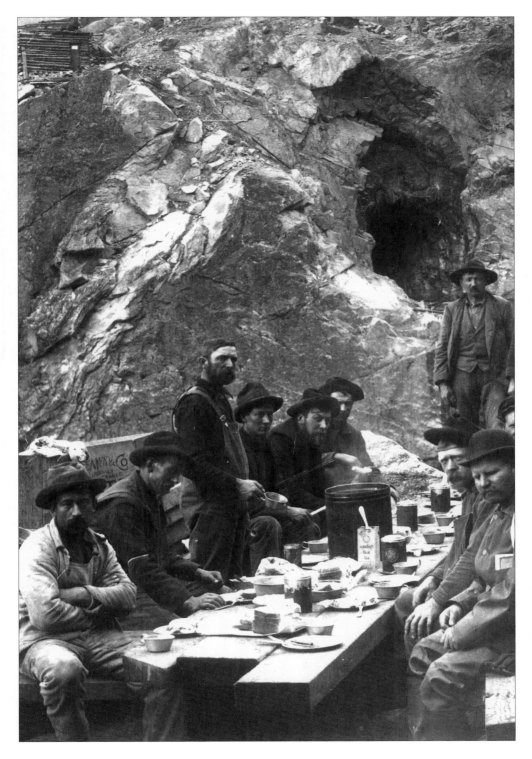

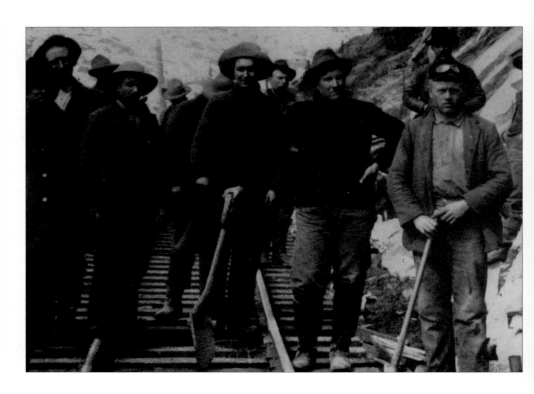

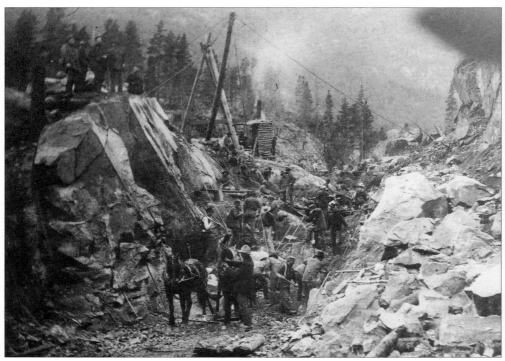

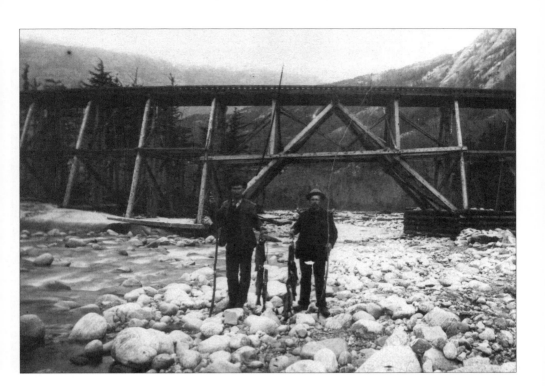

Opposite Top: Railway laborers take a short break from their work. One worker in the center is thought to be a woman. May 1898.

Opposite Bottom: Laborers with pick axes, sledgehammers and shovels clearing the grade of boulders. A team of horses in the foreground and a jerry-rigged hoist in the background are used to remove the larger rocks. August 1898.

Above: Two fishermen posing in front of trestle railway bridge 5A. ca. 1898.

"What in your opinion, will be the effect on business interests and property values of the building of the railway?"

E.R. Peoples, Undertaker: "The road will not benefit the street, but what is the use of kicking. Let 'er go."

A.I. Cheney, the Boston Store: "I am opposed to the railroad on Broadway for several very good reasons. First, the street is too narrow for business and a railroad, and second, when we are able to obtain insurance in Skagway, the fact that there is a railroad on Broadway will cause rates to be the higher on this street than anywhere else in the city."

Mrs. A. Crawford: "I think the railroad is a good thing and will help our street. Hot today, ain't it."

S. Bauer, Boss Baker: "Am glad the road is being built on Broadway, because I will not have far to go to put my famous bread on the cars and ship it to Dawson."

Skagway News, June 17, 1898

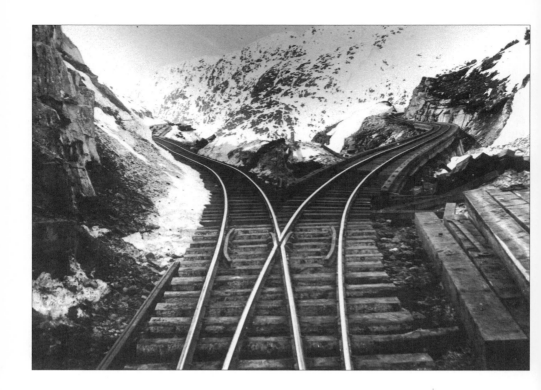

Where the festive little native squirrel would hesitate to venture, a railroad is being constructed, and constructed with that solidity and stability which only the ravages of time will weaken. The writer has traveled over the Canadian Pacific, Denver and Rio Grande, Cincinnati Southern, Baltimore & Ohio in W. Virginia and Maryland, all of them penetrating rough territories, but we feel safe in asserting that the White Pass & Yukon road will, when it reaches the summit, have achieved the greatest civil engineering triumph ever awarded on the American continent... a railroad which shows the most gigantic engineering skill and presents the finest scenic views to be witnessed from car windows in America, if not in the world.
The Skagway News, September 16, 1898

Above: View of the railway track splitting into two separate tracks at the switchback near the White Pass summit. May 1899.

Opposite: Another view of the hairpin switchback near the summit of the White Pass. 1899.

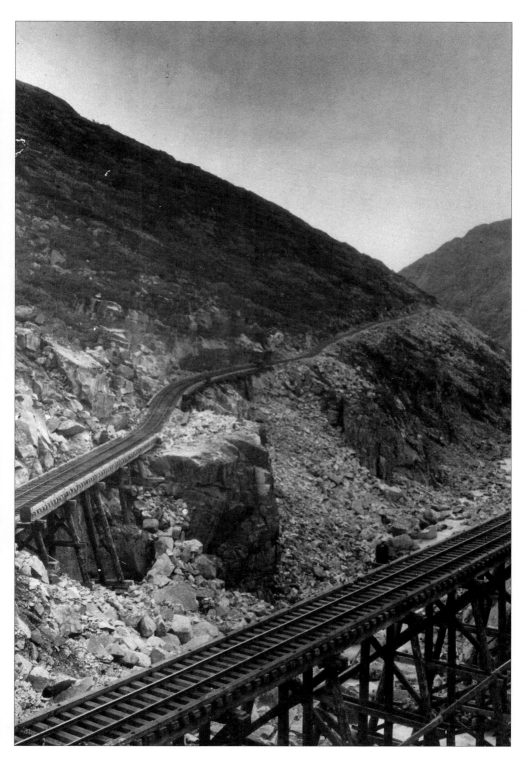

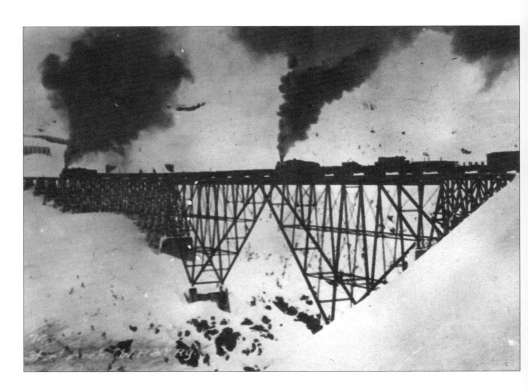

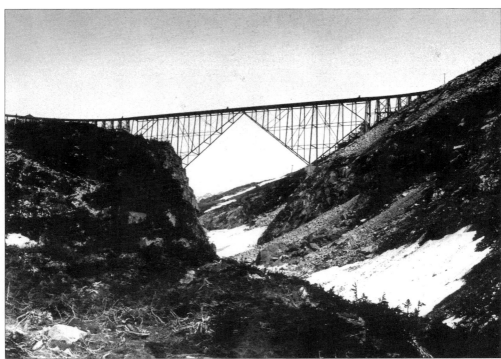

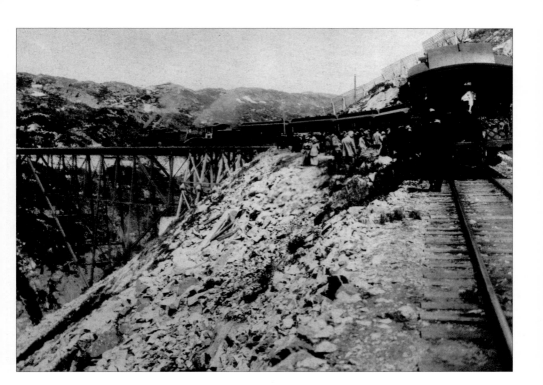

Opposite Top: Two steam engines belching smoke and pulling cars over Dead Horse Gulch cantilever bridge.

Opposite Bottom: Another view of the steel cantilevered bridge spanning Dead Horse Gulch near the summit of White Pass, ca. 1901.

Above: Train stopped at bridge over Dead Horse Gulch.

Never in the history of railroad building in the west has such rapid progress been made as that inaugurated on the Skagway & Lake Bennett enterprise. The road is now completely graded from tide water to the foot of Porcupine Hill; the piling has all been driven for the long bridge across the river, and the numerous small bridges are being rapidly put in, while over a mile of track has been laid, and a mighty fine track it is, too. Mr. Hawkins and Mr. Heney, the contractor, have gone to the Sound after more help, and will, if possible, bring back 600 or 700 men with them. After that the work will be pushed more rapidly than ever.

The Skagway News, June 17, 1898

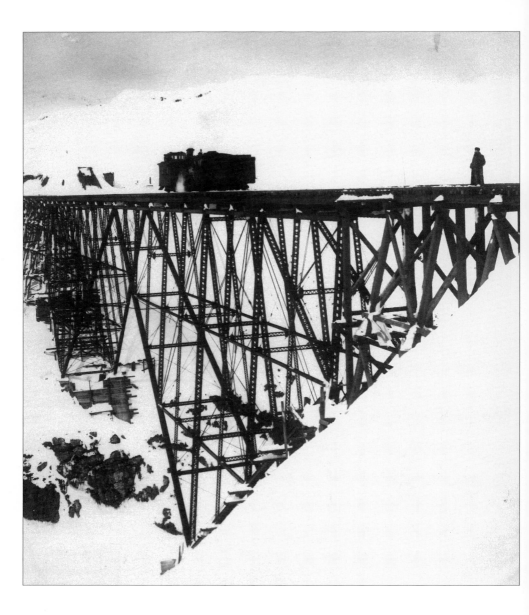

The White Pass and Yukon Railroad is a revelation, a fitting climax to the thousand miles of inland sea that stretches from Seattle to Skagway. Nature's art gallery seems unfolded in the panorama of mountains, glaciers, gorges, cascades, valleys, and streams that can be seen from a car window on this road.
Katherine Louise Smith, January, 1908

Above: Winter scene of a train stopped in the middle of the steel cantilever bridge spanning Dead Horse Gulch. April 1901.

Opposite: A train stopped on the trestle bridge in front of the tunnel.

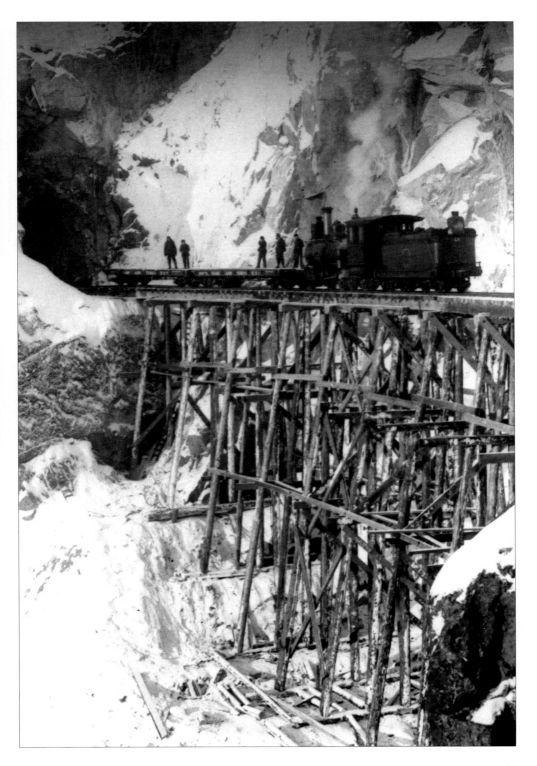

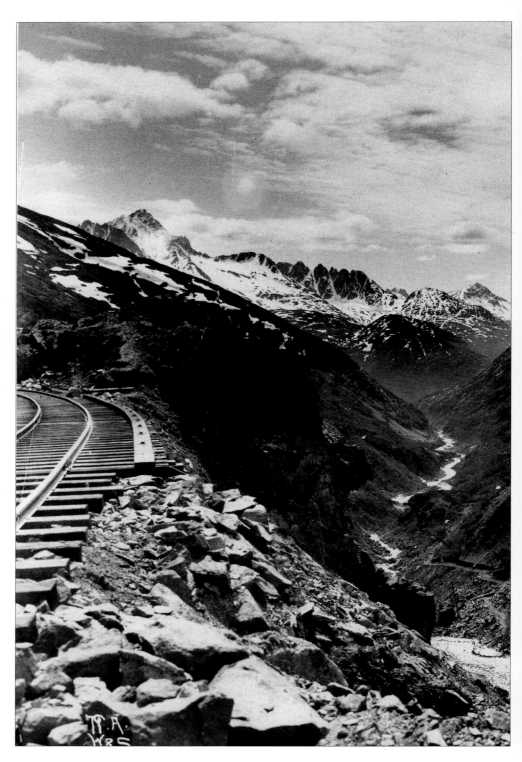

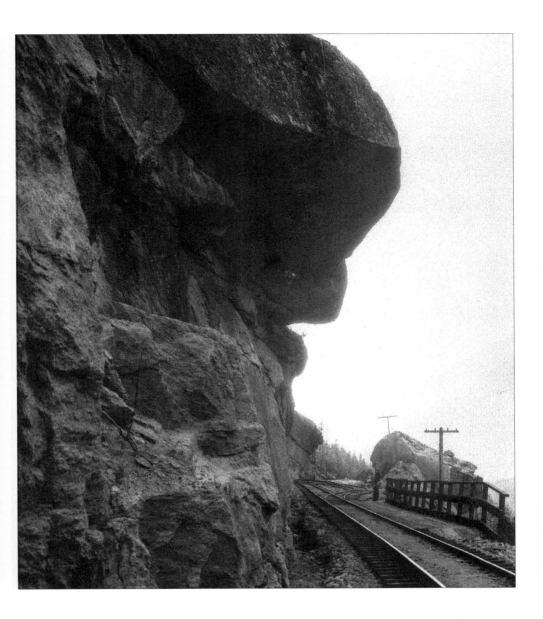

Opposite: Panoramic view of Cut-Off Canyon. 1899.

Above: A view of the overhanging rock at Clifton. 1899.

As the tourist on the train nears the summit and looks across the deep narrow rocky canyon, and sees the old trail winding in and out among the rocks and notes its steep ascent, he will wonder at the nerve and pluck of the indomitable gold-seekers who scaled these dizzy heights carrying on their backs or dragging on hand sleds in many relays covering weeks of the most arduous toil, their entire equipment for the goldfields.
E.S. Harrison, Alaska-Yukon Magazine, May 1907

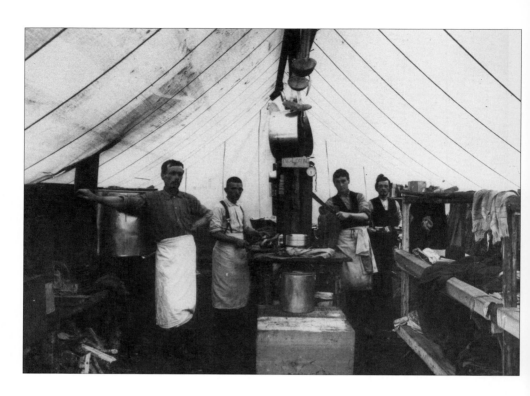

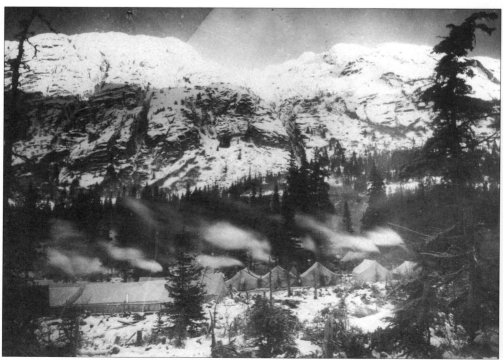

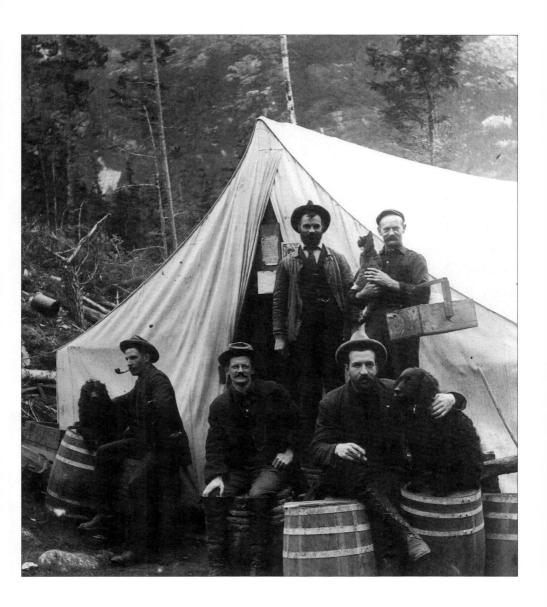

Opposite Top: Cooks posing inside their tent kitchen/bunkhouse. Visible are the water barrel, stove and wood pile, pots, ladles, loaves and bread, and bunk beds. 1898.

Above: Workers pose on wooden barrels in front of a tent in a construction camp. August 1898.

Opposite Bottom: Winter view of tents among the trees of Camp 8 near Glacier, Alaska. November 1898.

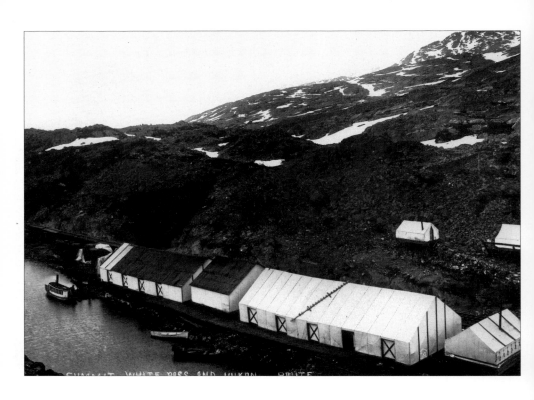

SUMMIT WHITE PASS AND YUKON ROUTE

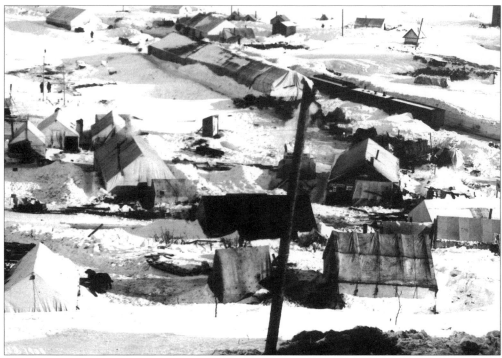

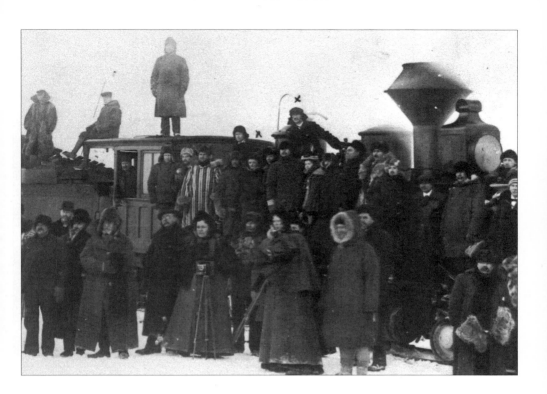

Opposite Top: The rocky alpine summit of the White Pass. A small boat and canoes can be seen on Summit Lake. 1899.

Opposite Bottom: The White Pass summit was cold and snowy most of the year. Maintenance crews worked long hours under extremely challenging conditions.

Above: A group of passengers and locomotive for the first excursion train to the summit of the White Pass. February 1899.

Good Dame Nature, arrayed all in virgin white under a bright sun and a cloudless sky, smiled and looked her prettiest on the mighty bleak summit of the great White Pass yesterday, in honor of the arrival at that elevation of the first through passenger train ever sent out from Skagway over the now famous White Pass & Yukon Railroad....One hundred guests... were invited to witness the completion of the gigantic undertaking of building a railroad to the summit, to the end of the American line and the commencement of the same line on British Columbia territory on toward Bennett.

The Daily Alaskan, February 21, 1899

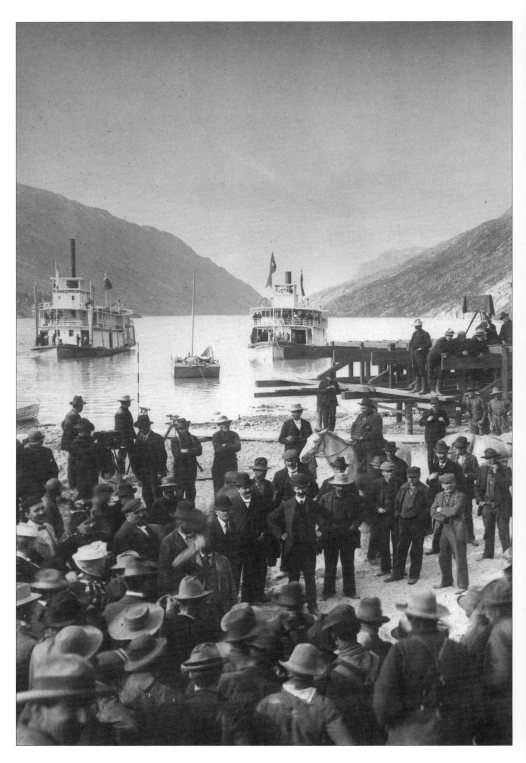

BENNETT AND BEYOND

Once over the White Pass summit, Heney faced less severe obstacles to building the railway. His seasoned crew reached the town of Bennett on July 6, 1899. Bennett had a population of 10,000 during the height of the gold rush although this tent town was rapidly becoming deserted.

Bennett held importance to the White Pass and Yukon Route Railway Corporation because of its proximity to Lake Bennett. Two barges were built at Bennett to haul cargo to Carcross. A trail at Carcross was used by horse-drawn wagons to carry goods to Whitehorse. This shipment of freight would help raise capital for the corporation and by the time the construction of the White Pass and Yukon Route Railway was complete, it had the unique position of having its construction costs fully paid-off as a result of these types of efforts.

The coast range was now behind Heney although he was not going to have an easy time building a railway across the rocky shores of Bennett Lake. The myriad small lakes and rivers enroute to Whitehorse would also pose difficulties. The seventy miles of track between Bennett and Whitehorse turned out to be much more challenging than anticipated and once again many speculated that Heney would be over budget or behind his schedule.

At Bennett, Heney divided his crew into two. The first crew laid track from Bennett to Carcross. The second crew laid track from Carcross to Whitehorse. The Carcross to Whitehorse crew reached Whitehorse in June 1900. The Bennett to Carcross crew was close behind, and on July 29,1900 the Golden spike was driven at Carcross. In total, the railway had cost ten million dollars and had taken 26 months to construct. Heney had built one of the most spectacular railways in the world.

Opposite: A large crowd gathered to watch the last spike being driven at Bennett. The Sternwheelers at anchor on Lake Bennett are the "Australian," "Gleaner" and the "Clifford Sifton."

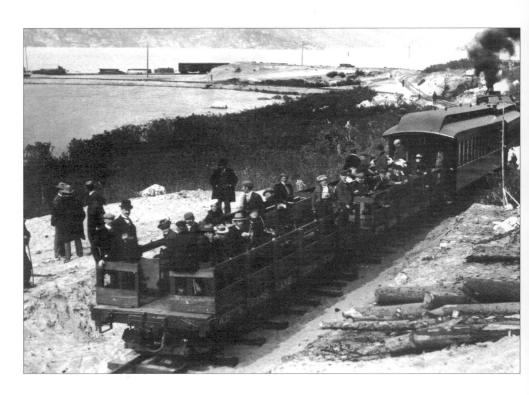

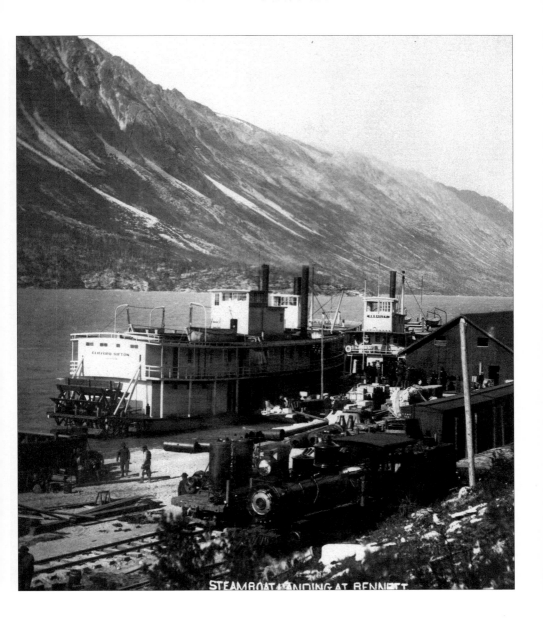

STEAMBOAT LANDING AT BENNETT

Opposite Top: Members of the Seattle Post Intelligencer excursion in an open train car as it approaches Bennett.

Opposite Bottom: Partial view of the train station at Pennington on the shore of Bennett Lake.

Above: A locomotive and cars by a freight shed. Sternwheelers "Clifford Sifton," "S.S. Bailey" and "Gleaner" are docked, and men, supplies and freight are visible on the dock and along the shore. 1899.

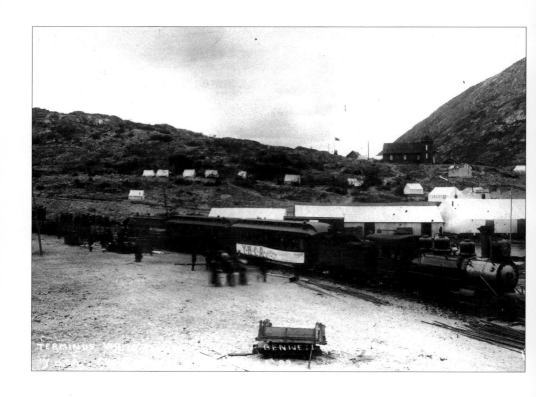

A little more than one year ago a company began what was then considered an impossible task, that of constructing a railroad from Skagway to the summit of White Pass. But where energy and money combine, defeat is unknown. Work was constantly carried on and never for one moment was there any flagging. Through a wild and rocky country where formerly the mountain goat dared not venture, a road bed was constructed, steel rails were laid over which thundered the iron horse drawing in his wake material for further construction....Yesterday the road was completed to Bennett, making it possible for travelers from any part of the United States to reach Dawson City on one continuous journey on rail and water where all the comforts of life may be enjoyed; no walking, no packing of outfits on backs of men and beasts, and with no delays.
The Daily Alaskan, July 1899

Above: A YMCA excursion from Skagway to Bennett. Old church and tents visible in the background. August 1899.

Opposite Top: A large group of people on the flat cars of the first passenger train to leave Bennett. This train also carried $500,000 in gold dust. Freight wagons, tents and the sternwheeler "Clifford Sifton" are visible. July 1899.

Opposite Bottom: Tents and the few wooden buildings that comprised the White Pass and Yukon Route station at Bennett. February 1900.

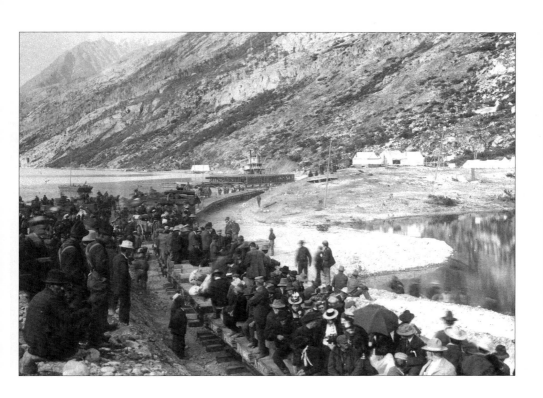

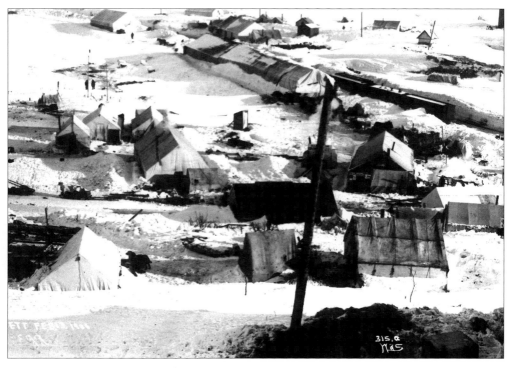

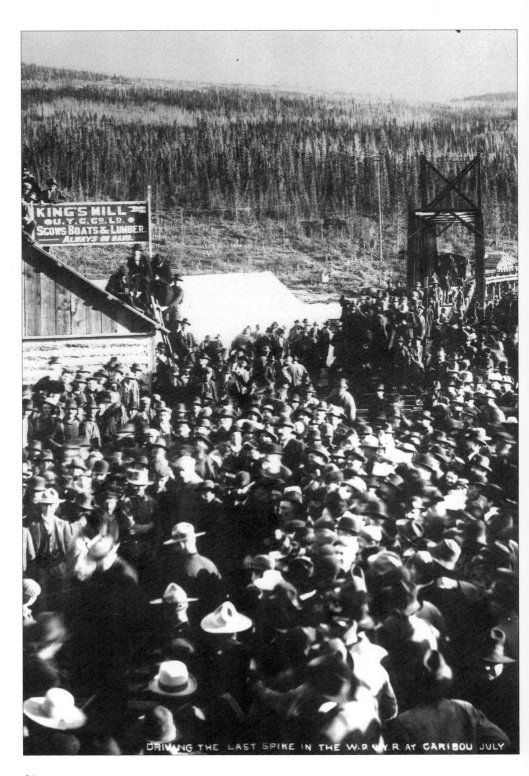

DRIVING THE LAST SPIKE IN THE W.P. & Y.R. AT CARIBOU JULY

A TOAST TO MICHAEL HENEY

This poem was written in 1900 and inscribed "A souvenir of Alaska and a White Pass and Yukon tribute from his friends to the man M.J. Heney."

O'erhead there are twin flags flying
To honor the winter day;
There is honor for each one present,
And for many far away,
There is honor for all the leaders
For those who schemed and planned,
As well as for those who found the coin
And for those who took command.

There is honor for all the army,
For the living and dead,
(for to some of high as of low degree the
grade to the church yard led);
But courage and science have conquered
While people have laughed and jeered
At the men who had faith and patience,
And never trembled or feared!

'Tis a thing they may all remember,
and every one may be proud,
In the years to come to tell his boys
That he was one of the crowd,
Not many can say they have labored
More steadfastly heart and soul,
Than the men who fought to unite the south
To the country round the pole.

A huge crowd of spectators watches the last spike being driven at Carcross (also known as Caribou Crossing.) This event marked the completion of the White Pass and Yukon Route tracks from Skagway to Whitehorse. July 29, 1900.

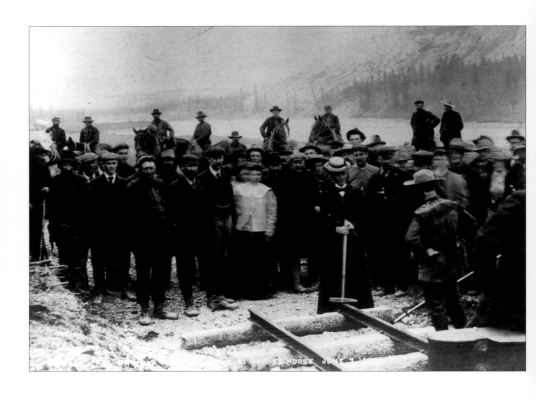

M.J. Heney, the railroad contractor, who was in the city
yesterday, announced that track laying on the extension of the
White Pass & Yukon road beyond Caribou will begin in ten
days, and now that spring has come and work can be done to
advantage along Lake Bennett, 1500 men are to be thrown into
action there just as soon as possible. He says further:

"I have 750 men employed on the extension at present
and have sent to the Sound for 2000 more. Every man that
applies is being engaged. It is the intention to rush the work,
and we hope to have the track completed so cars can go through
from Skagway to Closeleigh by the latter part of July. Three
hundred and fifty men of my present force are working along
Lake Bennett.

In track laying beyond Caribou we shall put down
thirteen miles at first, and then have seven more miles put down
a little later. I shall have everything in readiness for the
finishing of the track laying beyond Caribou just as soon as
navigation opens on Lake Bennett. Twenty-four hours after the
lake is opened we shall have the track laying finished to
Closeleigh."

The Daily Alaskan, April 1, 1900

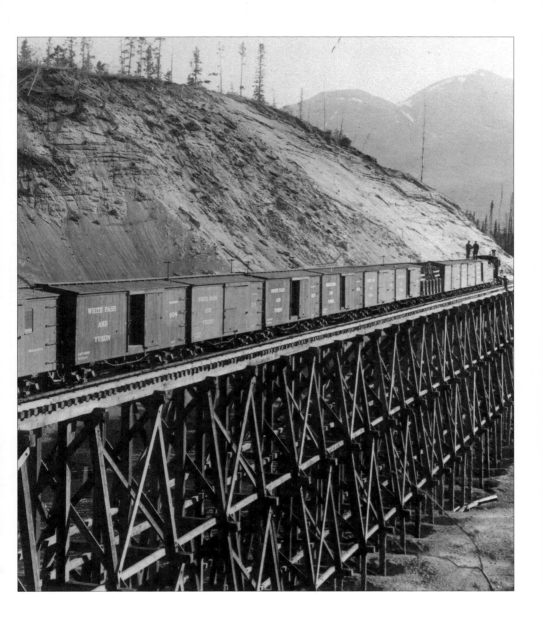

Opposite: First train into
Whitehorse. June 1900.

Above: A long line of boxcars
stopped on the timber trestle
spanning the outlet of Lewes Lake,
Yukon. Passengers are posing on
top of the last car. July 1900.
The water level of Lewes Lake was
accidentally lowered seventy feet
during construction of the railway.
The results of this disaster can be
seen to this day.

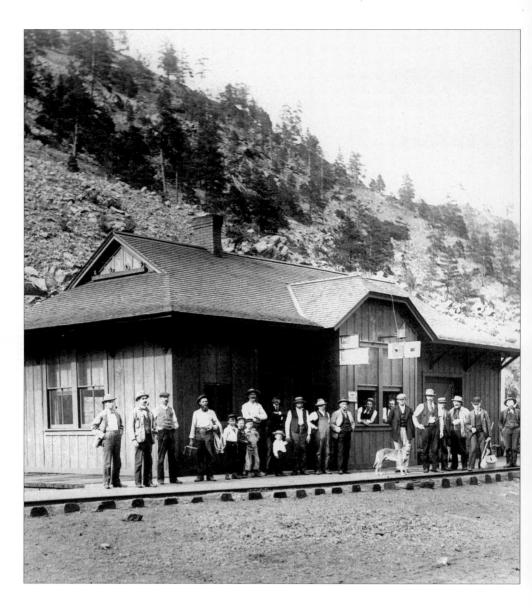

Above: A group of people in front of a White Pass and Yukon Route Railway station which also housed the Pacific Express Company office and the Western Union Telegraph and Cable office. 1901.

Opposite Top: A man and dog standing in the railway cut at Cowley Lake, Yukon (between Carcross and Whitehorse). January 1900.

Opposite Bottom: Work crews repairing the grade after a landslide at the big bend just outside Whitehorse. June 1900.

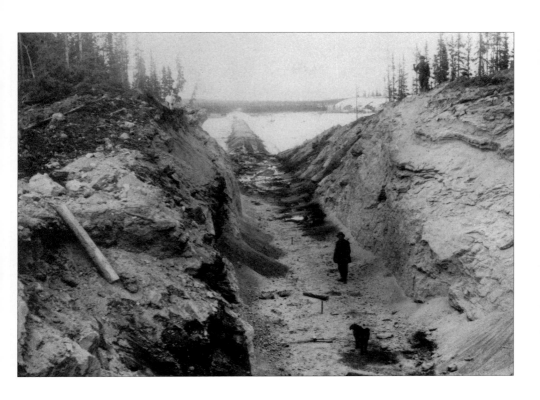

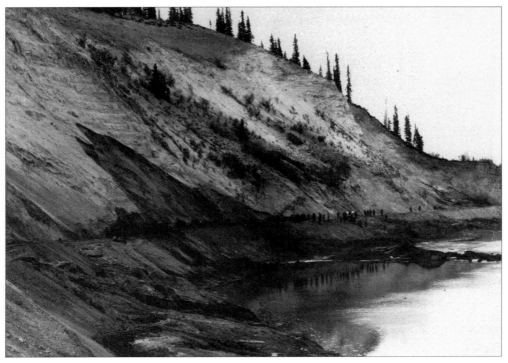

LOCOMOTIVES AND LUXURY COACHES

The manufacture of locomotives, boxcars and luxury coaches signaled the start of industrialization in Alaska and the Yukon. Raw materials and specific tradesmen were brought to Skagway and a railyard was founded. This ambitious undertaking was initiated before track had even reached the White Pass summit.

The manufacturing division was responsible for building most of the rail cars on the White Pass and Yukon Route Railway. At its peak, more than five freight cars were built in Skagway each week. Used locomotives from the lower forty eight were rebuilt and retrofitted to burn coal. Coaches were carefully crafted and equipped with woodstoves and plump bench seats. The railway soon had more than a dozen locomotives, passenger cars and more than 200 freight cars.

The machine shops allowed railcars to be built with northern conditions in mind. Being a thousand miles north of Seattle was a drawback if materials were unavailable or complicated repairs had to be made. Certain pieces of equipment, such as the steam–driven rotary snowplow, required frequent maintenance and were easily damaged in the punishing conditions of the north. The stockyards allowed sturdy railcars to be made locally and ensured the reliability of the railway.

While crews built trains and laid track, teams of carpenters constructed a network of train depots, water towers and coal bunkers. These specialized buildings ensured the safe and reliable operation of the railway. The Victorian architecture of the train depots in particular provided a simple elegance to the railway. These aesthetic considerations enhanced the image of the White Pass and Yukon Route Railway, and a romantic mystique followed its passengers long after their journeys ended.

Passengers standing in front of a caboose parked under the hanging rock at Clifton. 1901.

The train pulled out just before noon and proceeded as far as the rails are laid, where most of the passengers then alighted and walked a distance along the road bed, where rails are not already laid, but ballasted. One of the Boston professors was deeply grieved to find so large a body of men actually working on the Sabbath. He would not, under any circumstances, take stock in a railroad that permitted its men to work on that day. The Daily Alaskan, July 25, 1898

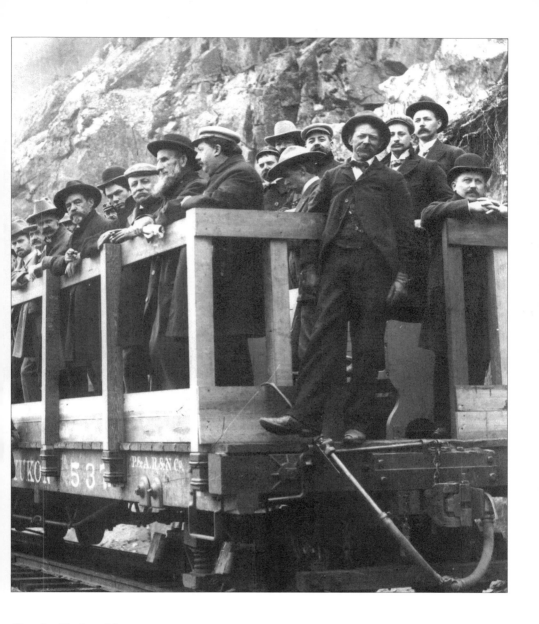

*Opposite: Members of the
Presbyterian Synod standing in an
open flatbed car at Glacier, Alaska.
August 1899.*

*Above: Members of the Senatorial
Party in an open flatbed car.*

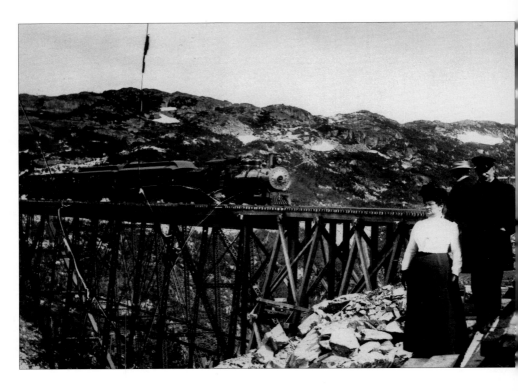

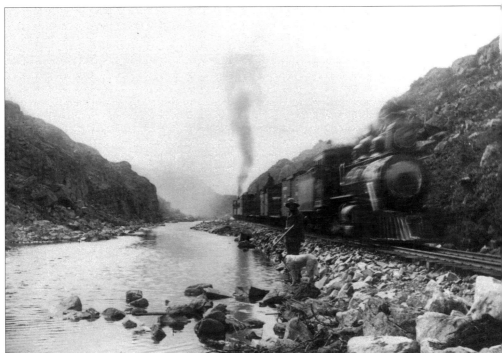

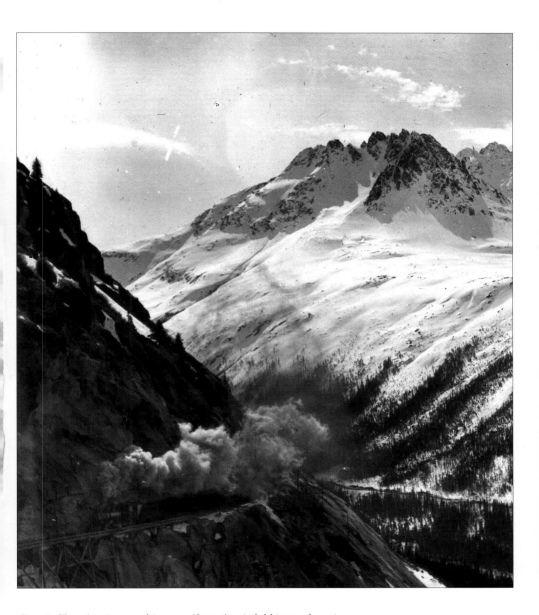

Opposite Top: A train stopped in the middle of the steel cantilever bridge spanning Dead Horse Gulch near the summit of the White Pass. Construction of the bridge was completed in early 1901.

Opposite Bottom: A hunter and dog standing next to Summit Lake as a train speeds past. August 1899.

Above: A train belching smoke as it winds around the face of Inspiration Point.

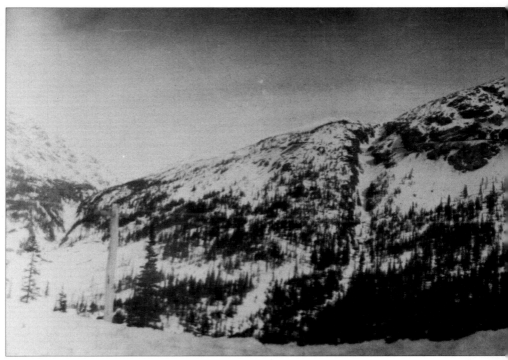

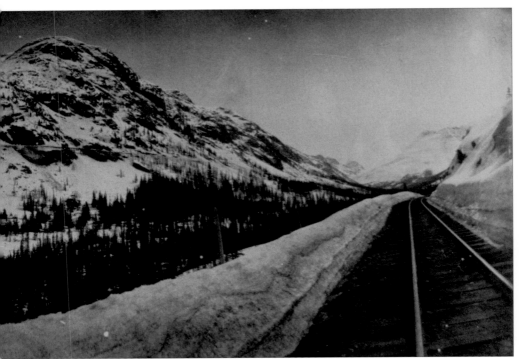

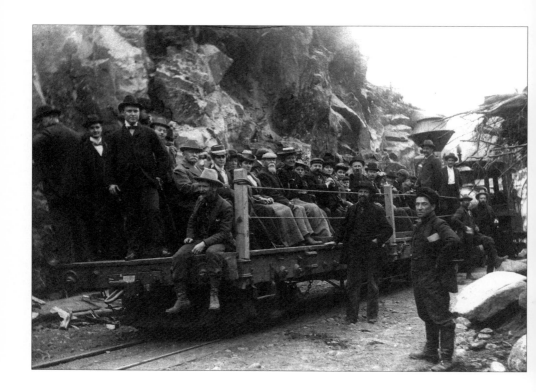

One very beautiful woman with gold-rimmed lorgnette, narrowly watched the wagon road as the train came home again. "All those horrors of the trail we read last year was wicked newspaper talk. We have country roads outside Boston worse than that trail, and men and horses don't lose their lives on them." Someone remarked that the trail so much had been written about was hidden in the woods on the other side of the river and at Liarsville - "Ah, Liarsville," she angrily ejaculated and declined to hear more.

The Daily Alaskan, July 1898

Pages 66 and 67: Panoramic views of mountain scenery.

Above: Passengers on an open flatbed car at Rocky Point.

Opposite Top: YMCA excursionists standing on an open flatbed car at the White Pass summit turntable. August 1899.

Opposite Bottom: A group of women passengers posing on a flatbed car. June 1899.

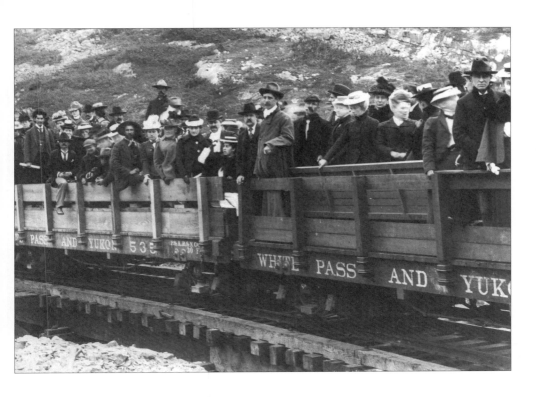

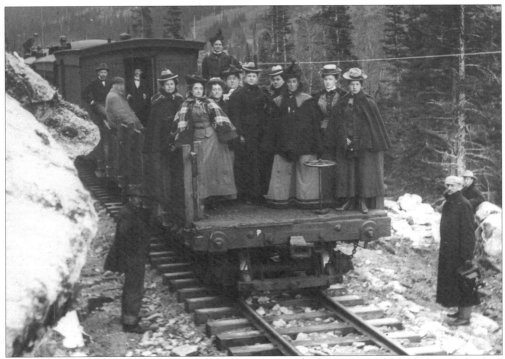

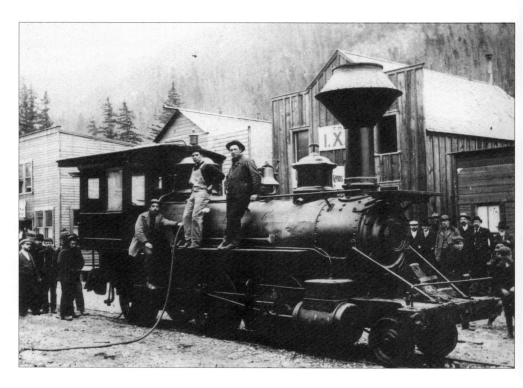

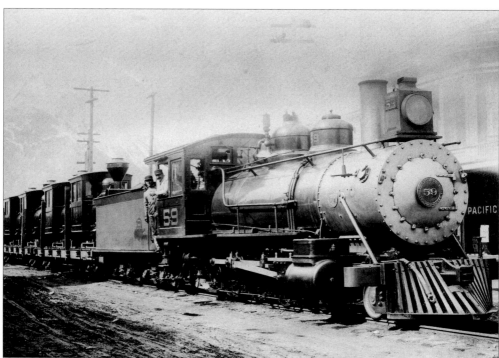

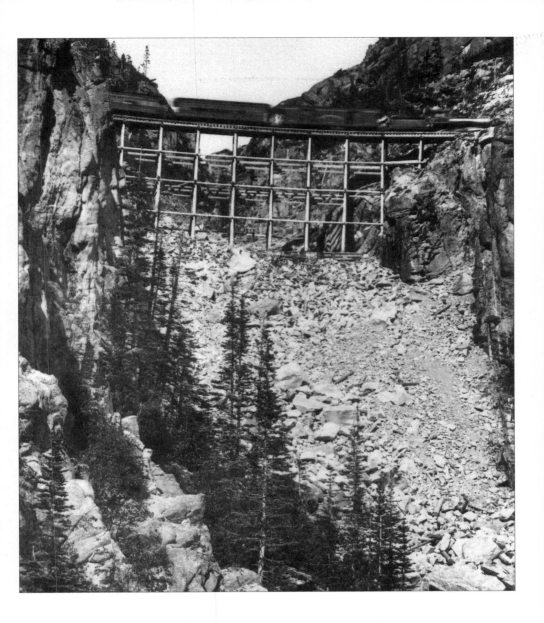

Opposite Top: Men posing on
Alaska's first locomotive, in
Skagway. July 1898.

Opposite Bottom: Locomotive 59
on Broadway Avenue, Skagway,
ca. 1904.

Above: Train speeding across the
timber trestle spanning Glacier
Gorge. June 1901.

*One may have tired from sympathy with laboring engines that
lifted the train to a station on the top of the mountain, but one
will now feel rested as the train starts and glides over a
comparatively level track and excellent roadbed without apparent
effort, along the shores of the mountain lakes, the courses of
rushing mountain streams, and all the time by the base of the
angular hills, possibly some of them snow-covered, which make
a broken landscape on this side of the mountain range.*

E.S. Harrison, Alaska-Yukon Magazine, May 1907

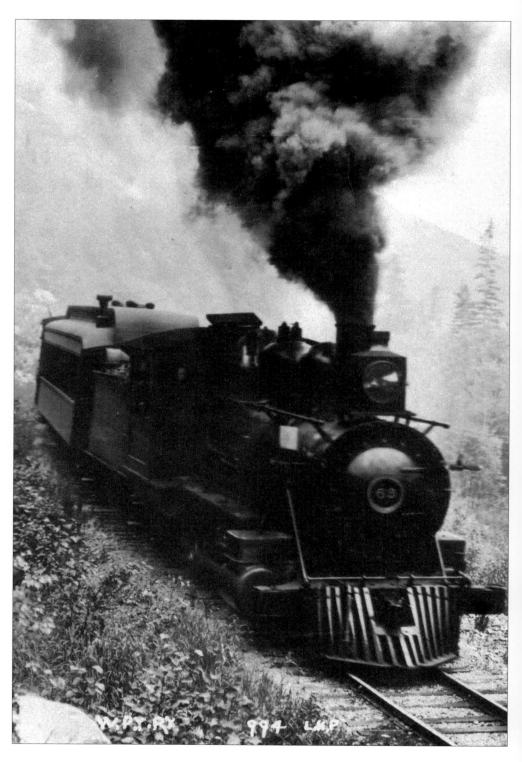

W.P.Y. RY. 994 L&P

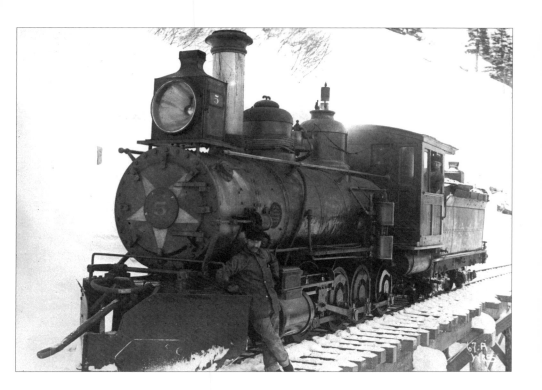

Opposite: Train belching smoke bound for White Pass summit.

Above: Two trainmen pose with their locomotive during the winter of 1900.

The train leaves Skagway and starts up the canyon with many windings, as the engineers have utilized all the linear space possible in order to reduce the grade. This journey to the summit, over a railroad in places blasted along the edge of a ledge of rocks where the traveler may look down 1,500 feet below, through tunnels and across steel bridges that span mountain gorges, is now made in four hours.

E.S Harrison, *Alaska-Yukon Magazine*, May 1907

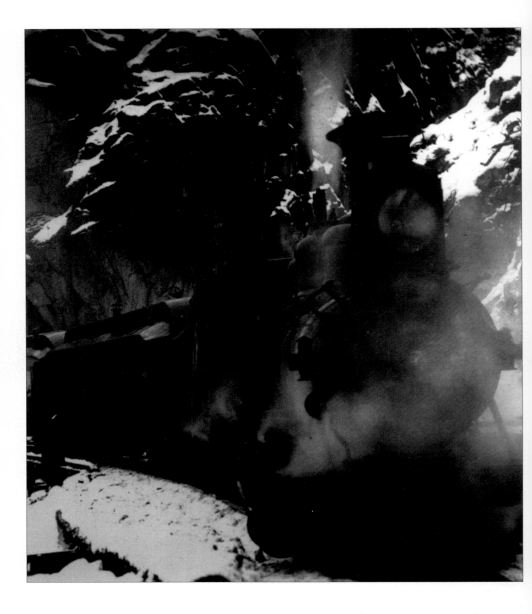

The evening train which was delayed until 11 o'clock last night came in loaded with Klondikers burdened with gold dust. As near as could be estimated there was a ton of dust brought in. *The Daily Alaskan, July 7, 1899*

Above: Locomotive 7 pulling passenger coaches and boxcars. December 1899.

Opposite Top: Locomotive 66 at the station in Whitehorse.

Opposite Bottom: A locomotive rounding the bend at Rocky Point, after a steep climb up the grade. 1899.

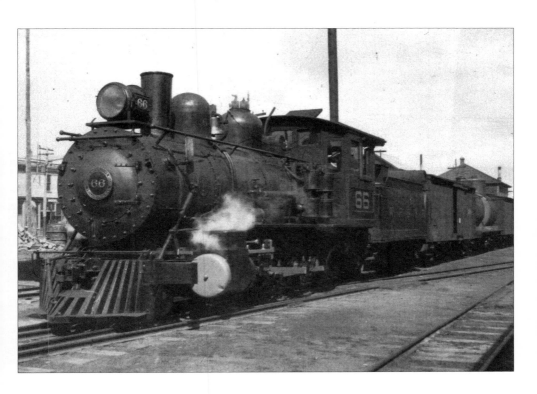

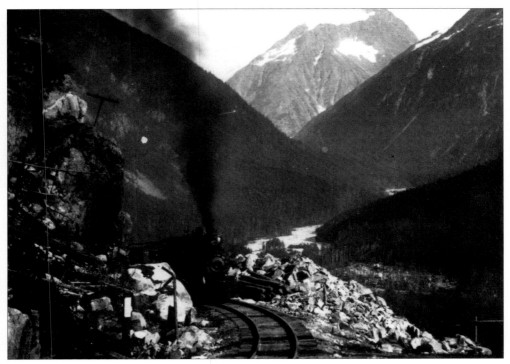

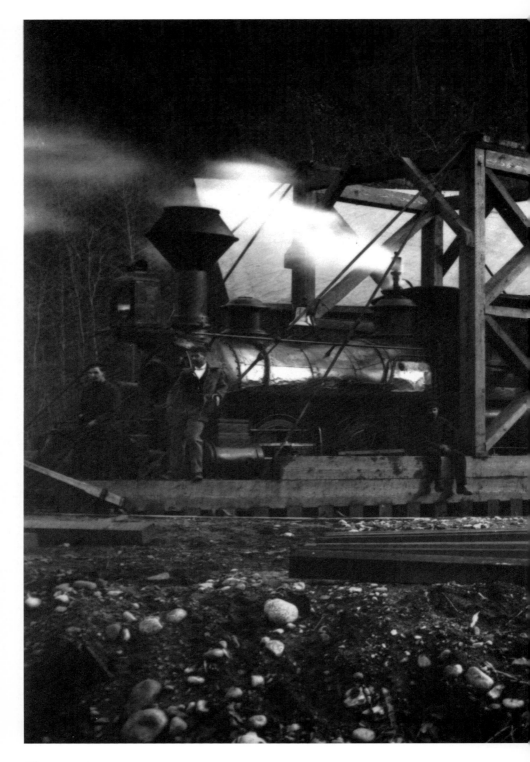

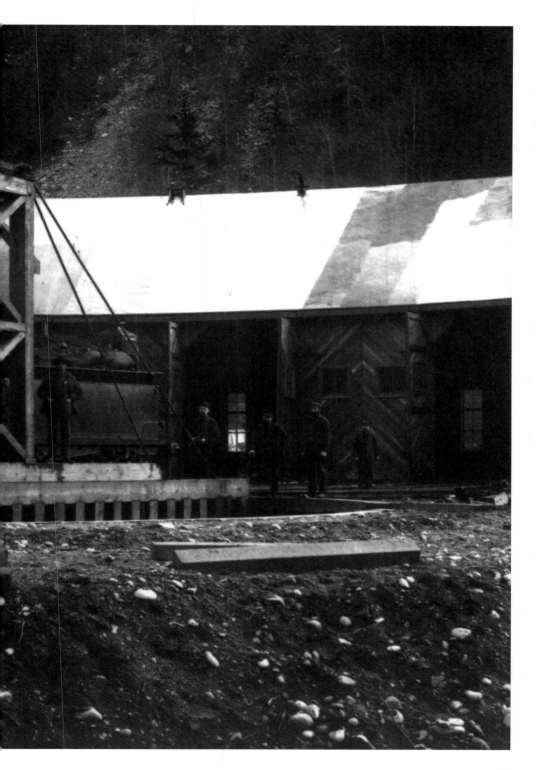

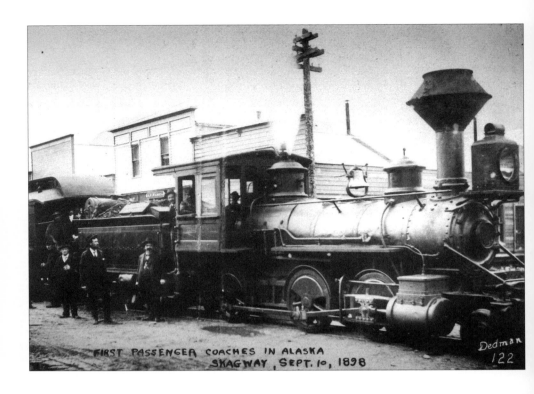

FIRST PASSENGER COACHES IN ALASKA
SKAGWAY, SEPT. 10, 1898
Dedman
122

Skagway's car shops are just now one of the busiest industries in Alaska. These shops are the property of the White Pass & Yukon Route...(and) are now turning out five box cars a week.

One hundred cars have been built here since last fall. Seventy-five more are to be built under the present order.

Eighteen men are employed in the car building department proper and twenty-four others in the machine shops, blacksmith shops and brass foundry and other departments of the shops.

The total of 175 cars embraced in the number built since last fall and those now being turned out include box, cattle and flat cars....

The lumber used in the construction of these cars is all received here in the rough and every part of the wood work is done in the local shops. The car frame is made, finished and equipped with trucks and other appurtenances, and the finished product when rolled out, is an admirable piece of the handiwork of man.

The Daily Alaskan, March 10, 1900

Above: Crew and passengers standing alongside the first coaches and locomotive on Broadway Avenue, Skagway. September 1898.

Opposite Top: Locomotives 4 and 5 and coach cars.

Opposite Bottom: Locomotive pulling a long line of flatbed cars loaded with freight destined for the Yukon. November 1898.

Pages 76 and 77: A round house turned trains around in Skagway.

78

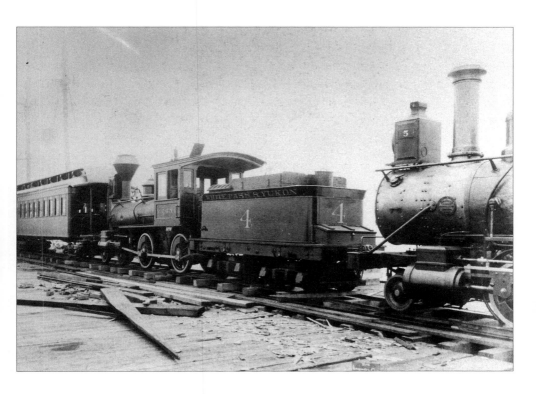

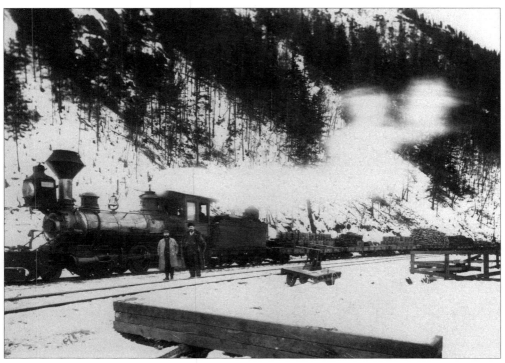

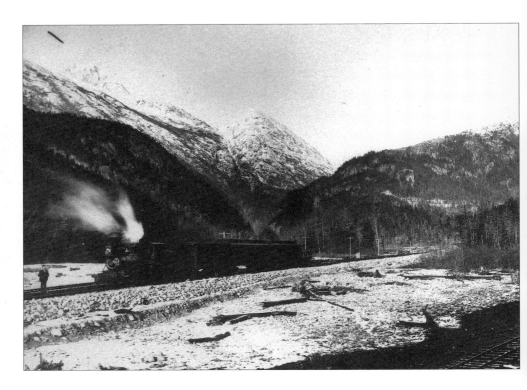

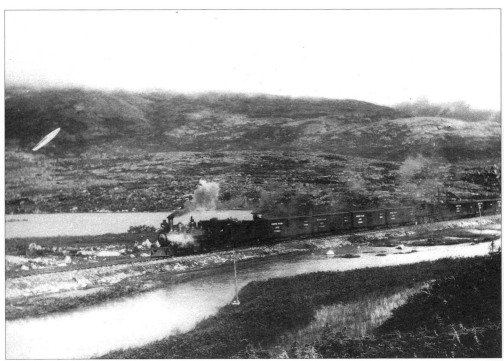

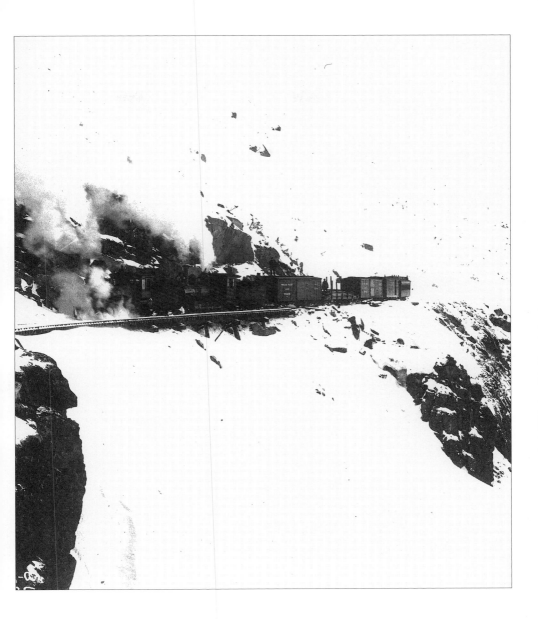

Opposite Top: Train stopped along the tracks in the flat, rocky section of the Skagway River valley approaching Skagway. 1899.

Opposite Bottom: A freight train with two locomotives traveling across the flat marshy ground known as Meadows, BC. August 1899.

Above: Two locomotives and freight cars puffing around a bend high in the coastal mountains during the winter. 1899.

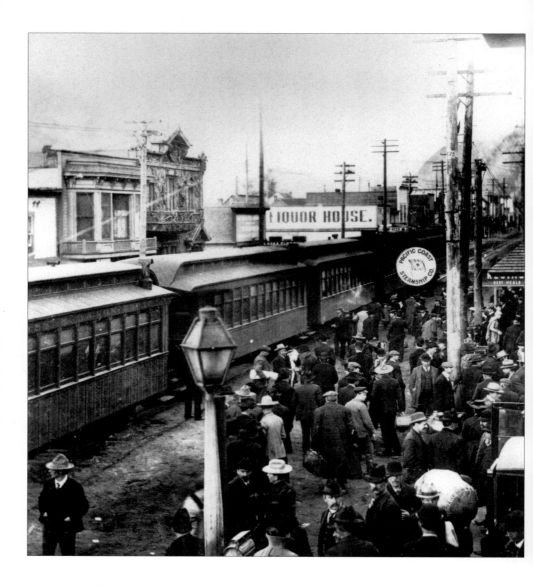

It is different from the other routes of travel that the tourist is wont to frequent. Being new, this route is not provided with everything in the way of equipment that people accustomed to luxurious environments might desire. There are no hardships to be endured, but the luxuries the traveler may find on an Atlantic liner he may not find on this trip. But he will be comfortable. And for what he lacks in the way of luxuries there will be more than compensation in sights to be seen and things to be learned about the wonderful Northland, the empire of more than snow wastes and frozen pay streaks.

E.S. Harrison, *Alaska-Yukon Magazine*, May 1907

Above: Passengers preparing to climb aboard a train stopped in front of the depot on Broadway Avenue. Arctic Brotherhood Lodge is visible in the background.

Opposite Top: Locomotive and caboose stopped on the tracks near Rocky Point. April 1901.

Opposite Bottom: A train on Broadway Avenue, Skagway, during a blizzard. 1899.

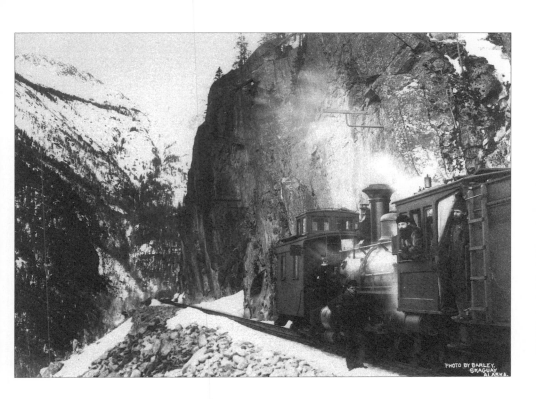

PHOTO BY BARLEY.
SKAGUAY
ALASKA.

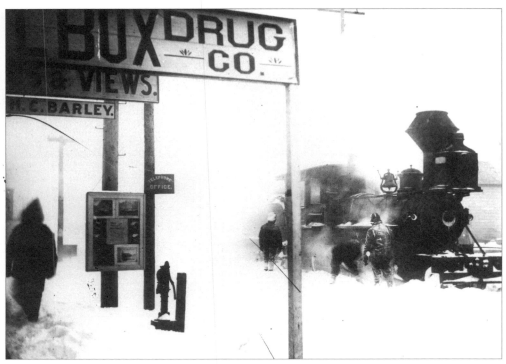

BOX DRUG CO.

& VIEWS.

H. C. BARLEY.

TELEPHONE
OFFICE.

83

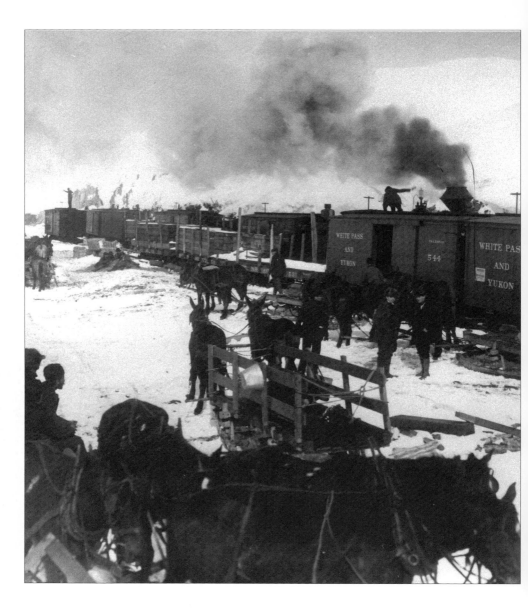

The gold in the frozen hills will attract the wealth-seeker; the picturesque scenery, the primitive conditions of an empire in process of birth, the natives with their queer quaint customs, and other features of this strange land, will attract the tourist.
E.S. Harrison, Alaska-Yukon Magazine, May 1907

Above: Men, horses and wagons at Summit Station to unload supplies. 1899.

Opposite: Passengers at the White Pass summit. July 1899.

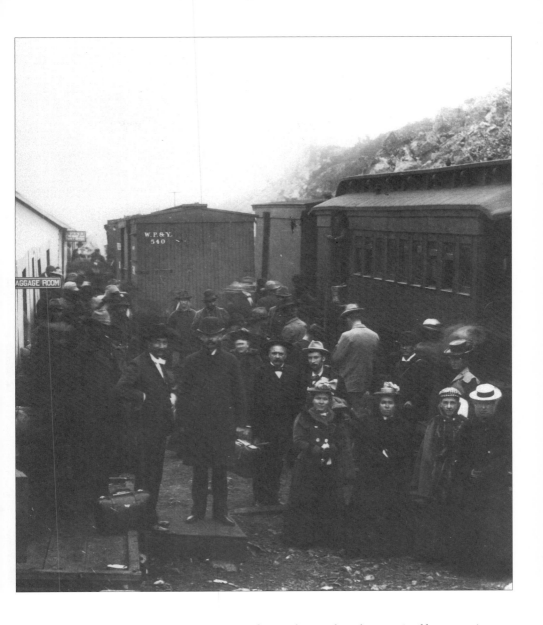

Every car is firm and staunch and as serviceable as any in use on the great railroad systems of the states. To look at the Skagway-made car a stranger would not know but what it was the product of some great eastern car company. Each car is of modern equipment in every respect.
The Daily Alaskan, March 10, 1900

85

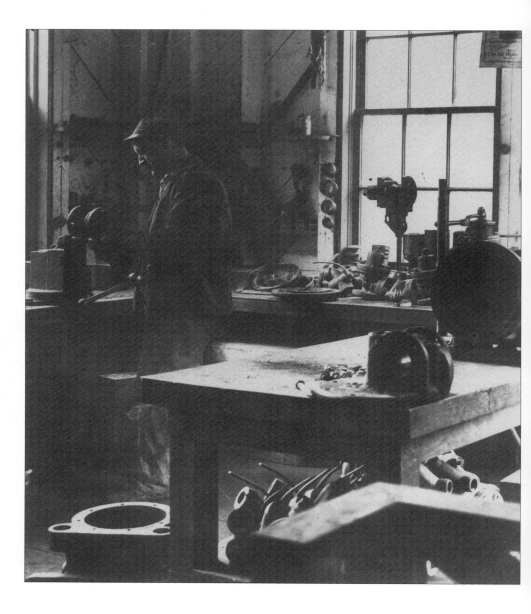

A 1500 pound steel hammer is just being installed at the shops. It arrived this week on the Al-Ki. This is probably the largest hammer ever brought to Alaska. In addition to the new box, flat and cattle cars being turned out, the company is soon to add to its rolling stock a number of fine, new modern locomotives. They have already been ordered. It is probable the company will also have one or two more snow plows for use next winter. *The Daily Alaskan, March 10, 1900*

Above: Interior view of a White Pass and Yukon Route Railway machine shop.

Opposite Top: Coal being loaded into a train from a bunker at the north end of Skagway. ca. 1901.

Opposite Bottom: Covered flatbed cars. ca. 1900.

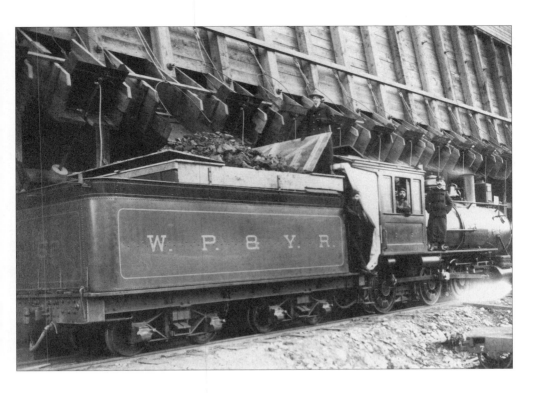

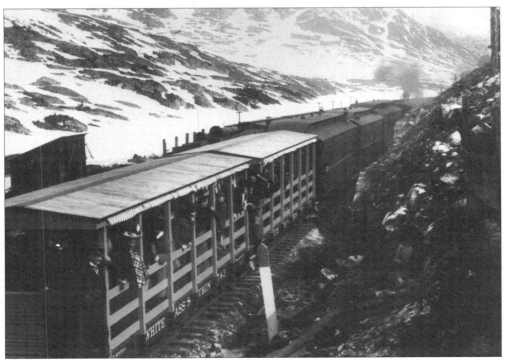

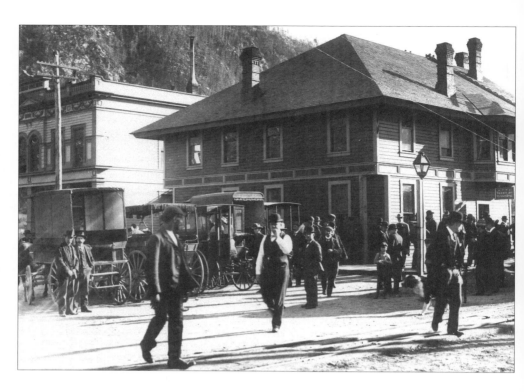

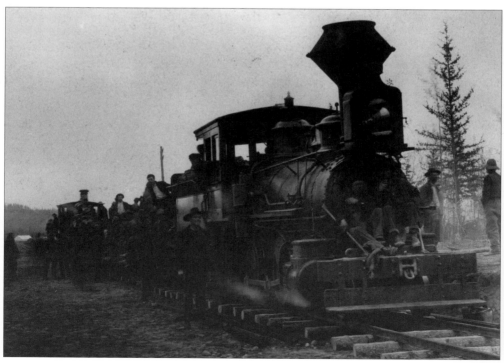

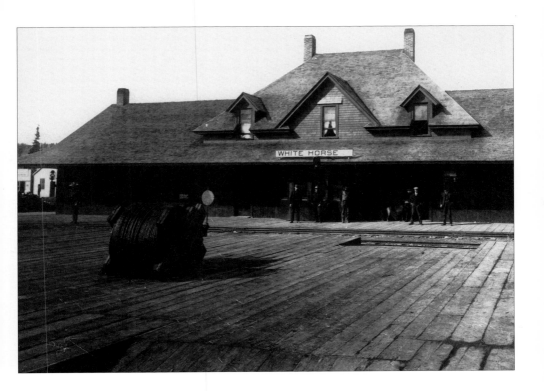

Opposite Top: People standing in front of the White Pass and Yukon Route Railway depot in Skagway. Horse-drawn carriages are lined up waiting for passengers. 1901.

Opposite Bottom: White Pass and Yukon Route Railway laborers standing in front of the train depot. Carriages from the Golden Northland Fifth Avenue Hotels are waiting to pick up passengers. December 1899.

Above: The train depot in Whitehorse located prominently at the end of Main Street. and Fifth Avenue Hotels are waiting to pick up passengers. December 1899.

When the eyes of the wondering world were turned to the new land of gold in the far north, when the rush to Klondike made towns grow in a week, Skagway was born and built a few miles from Dyea, which proudly claimed rank of a great and everlasting city.

But in two years' time Dyea was depopulated and dead - as dead as the old city of the cave dwellers in Arizona - and Skagway was a thriving town with a great wharf, a railroad and possessed of all the institutions which go to make a modern city. And Skagway will always be there, the natural gate opening up to the empire beyond. A hundred thousand square miles and more can be reached over Skagway only, and these vast regions bear promises of future discoveries of gold and copper, of coal and a host of other mineral products, besides millions of acres that some day will be claimed as homes of thousands.

Elias Ruud, Alaska Monthly Magazine, May 1907

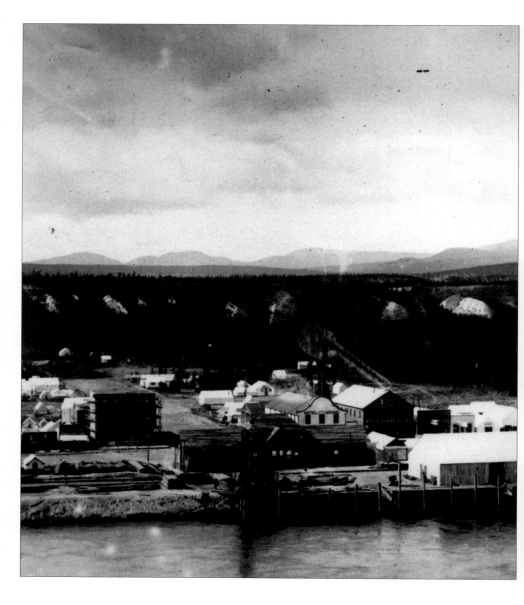

Above: Panorama of Whitehorse looking west across the Yukon River. Exteriors of Bennett News, Hotel Grand, White Horse Hotel, Arctic Restaurant and the White Pass and Yukon Route Railway terminal under construction. 1900.

Opposite Top: Passengers and train at the White Pass and Yukon Route station at the summit of the White Pass. June 1900.

Opposite Bottom: The train station at Log Cabin BC.

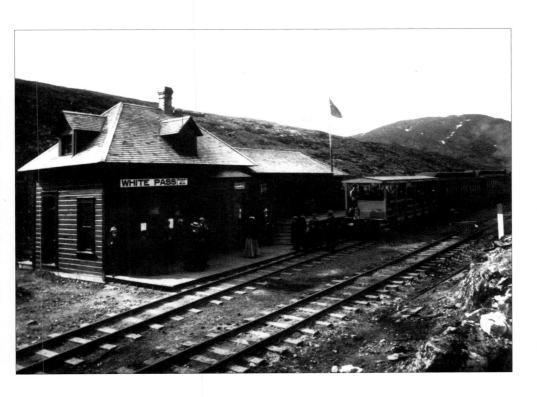

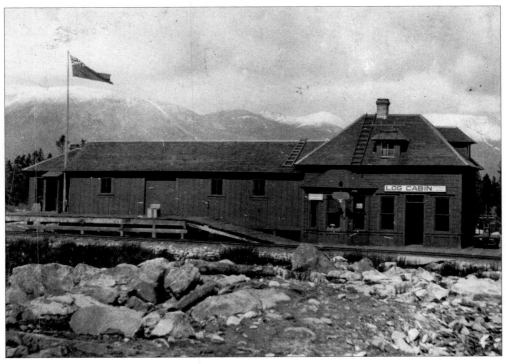

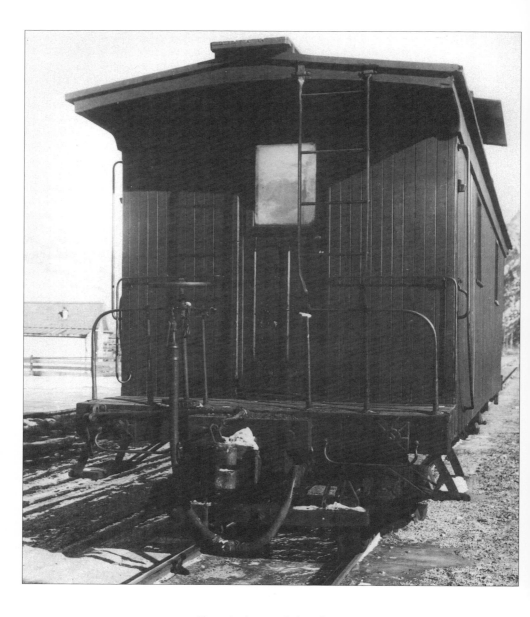

Above: A caboose parked on the tracks in Skagway, Alaska.

Opposite Top: A caboose attached to a locomotive in Skagway, Alaska.

Opposite Bottom: A train nearing Bennett, BC with two men standing on the observation deck of the last car. 1899.

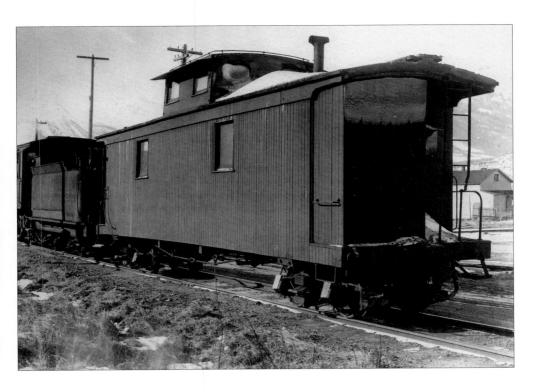

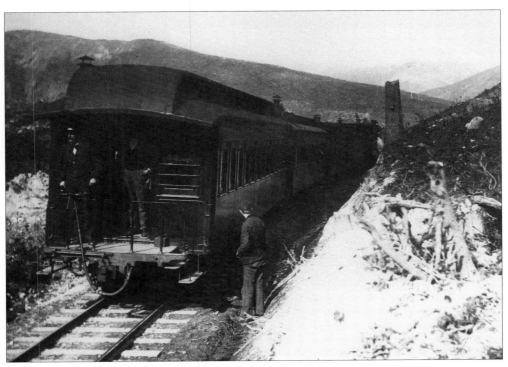

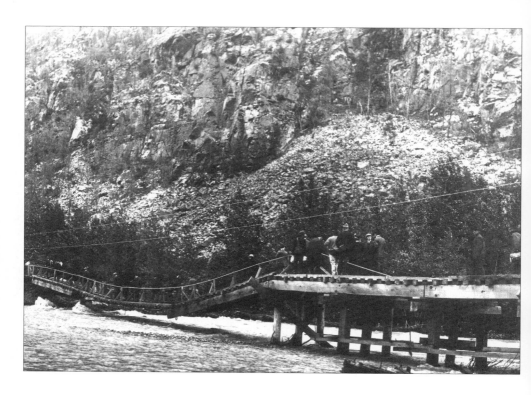

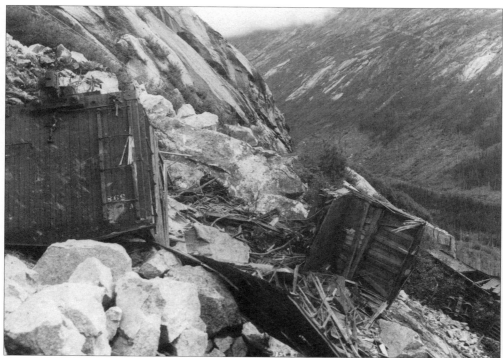

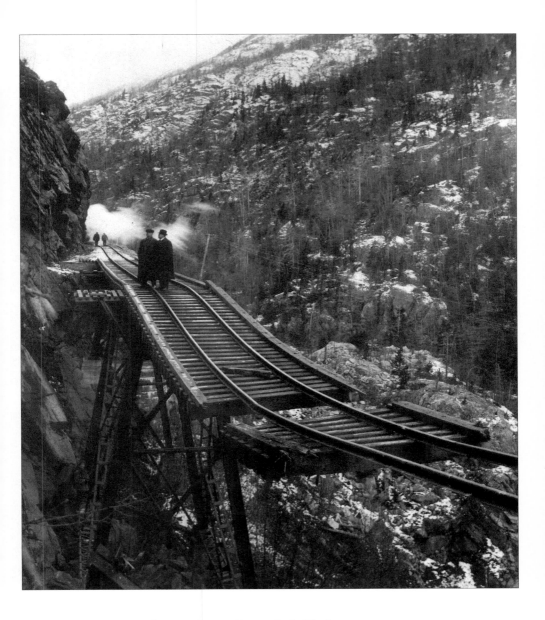

Opposite Top: High water on the Skagway River has on occasion removed bridge supports. Passengers are seen here carrying their luggage from the train over the sagging section of the bridge to the river bank.

Opposite Bottom: Rock slides from steep mountain faces have always posed a hazard of derailment.

Above: White Pass and Yukon Route Railway officials inspecting the damaged tracks supporting trestles of the railway tracks collapsed on a cliff face.

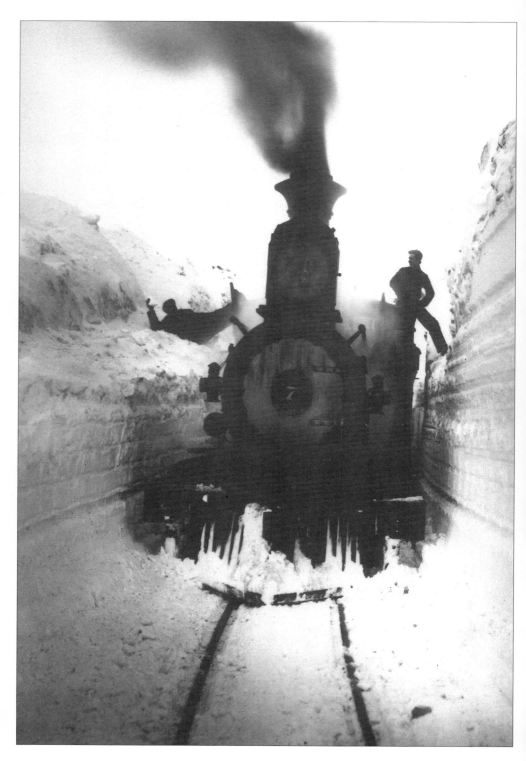

SNOW

The snow and cold of Alaskan and Yukon winters posed massive challenges for the construction and maintenance of the railway. Moisture-laden winds from the Gulf of Alaska mixed with the dry cold of the interior causing blizzards of epic proportions. Avalanches ripped down the mountainsides and tracks could be buried under tons of snow and ice within seconds.

During the construction of the railway, crews were limited to shifts as short as a single hour because of the cold. Building trestle bridges hundreds of feet above ground with numb fingers presented serious risks of falling. As a result, work slowed to a snail's pace. Heney's crews persevered and enough progress was made to justify the extreme effort and expense.

Maintaining the railway was more challenging than anticipated. At the White Pass summit, twenty-foot drifts were not uncommon, and storms could hit suddenly and last for days on end. In the railway's early days, one answer to these arctic conditions was the large workforce available in Skagway. Hundreds of men were hired for the back-breaking work of shoveling snow from the tracks.

To assist these efforts a rotary snowplow which was steam driven and mounted on the front of the train and handled by a ten-person crew was employed. Ten-foot blades chewed a tight corridor through drifts but were sometimes stopped by the massive amounts of dense coastal snow. In these instances, the train could be delayed for long periods. Wood stoves in the parlor cars were kept stoked and blankets distributed to all passengers. The crew was then relegated to shoveling a path for the train. In the worst conditions, a second train would attack the drifts from the opposite direction to assist in clearing a passage.

Locomotive 7 passing through the high snow banks on both sides of the tracks near Glacier. December 1899.

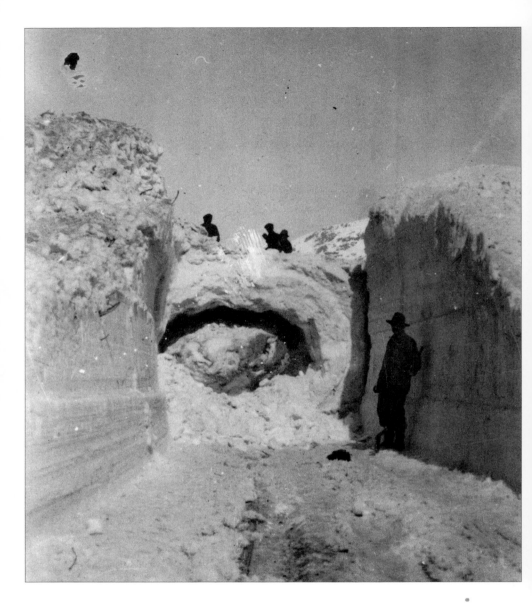

Above: A crew clearing snow from the train tracks. Walls of snow ten feet high line the tracks.

Opposite Top: Locomotives and a rotary snowplow attempting to clear the tracks near the summit.

Opposite Bottom: A train and crew passing an enormous snowbank. December 1899.

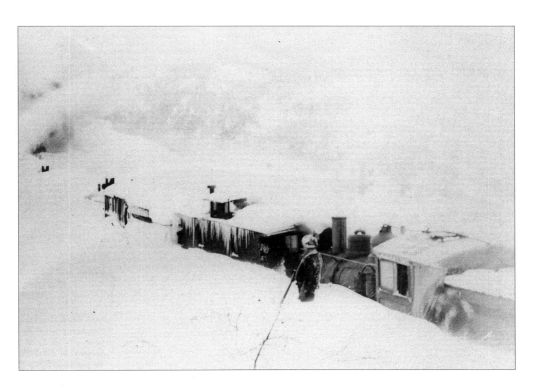

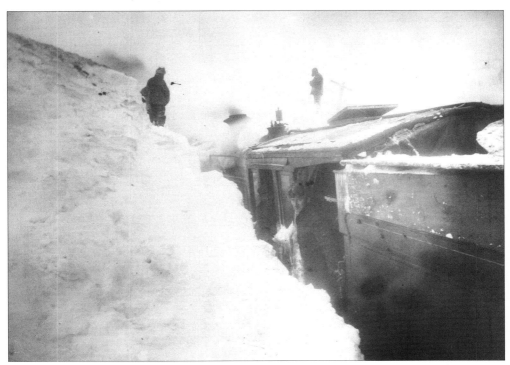

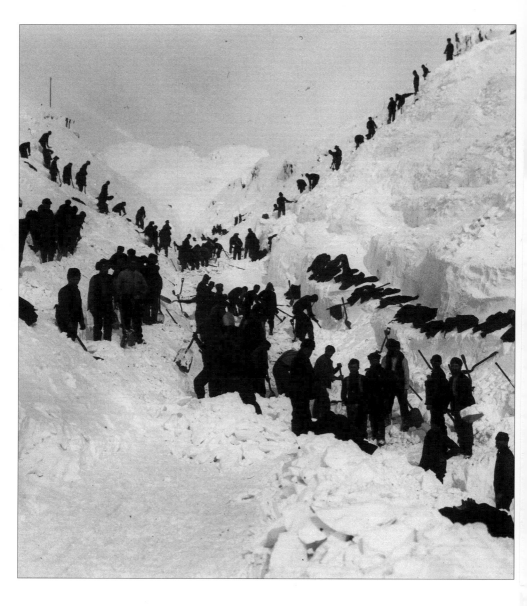

The same enterprise that surmounted the financial and physical difficulties in building the White Pass and Yukon Route has to be employed in keeping it open.
Enos Brown, Scientific American, February 1902

Above and Opposite: Workers shoveling snow from tracks after a storm at the summit of the White Pass. Hundreds of laborers were employed to clear the tracks after storms.

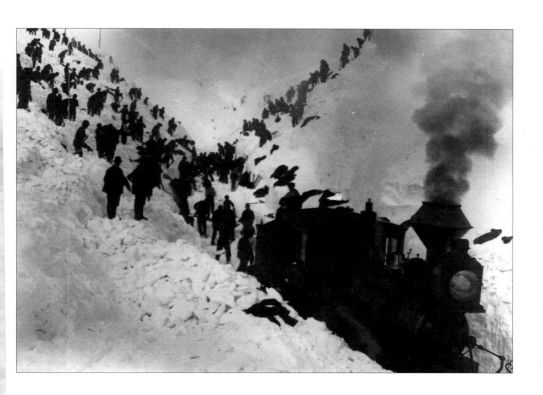

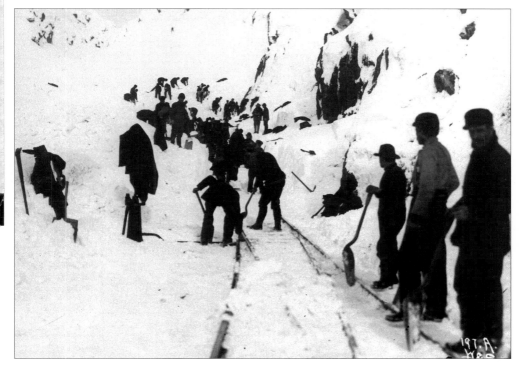

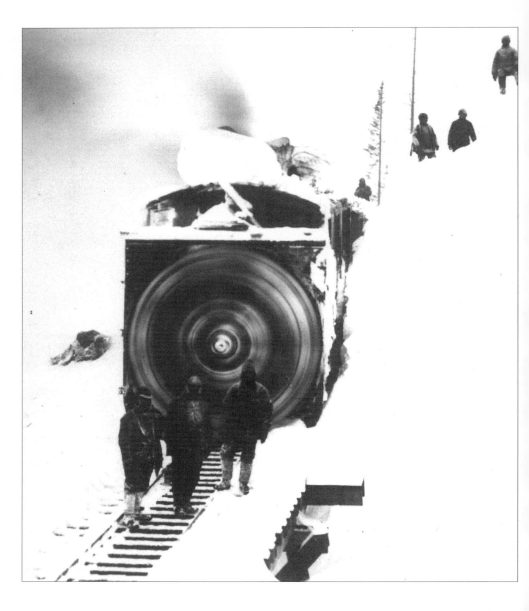

There was a decided change yesterday in temperature in Skagway. The mercury dropped from 40 above at 5 PM Wednesday to 11 above at midnight last night. At Bennett it went from 20 above to 20 below.
The Daily Alaskan, January 1900

Above: Workers standing in front of the rotary snowplow near the summit. December 1899.

Opposite: Crew posing with the rotary snowplow.

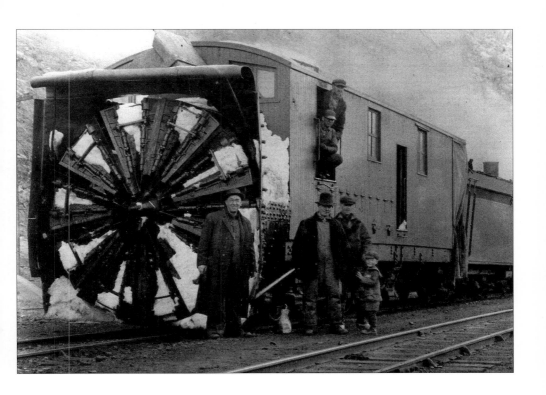

The passenger train which left here preceded by the rotary, at noon Wednesday, and with nearly two hundred passengers aboard, had not reached the summit at the time of going to press this morning, but all was reported well. The passengers were able to hustle up plenty of provisions, the cars were kept warm, and to those who were not in a hurry it was something of a picnic. The rotary is reported to be in good order, and working; but the snow is hard and the progress slow.
The Daily Alaskan, March 1900

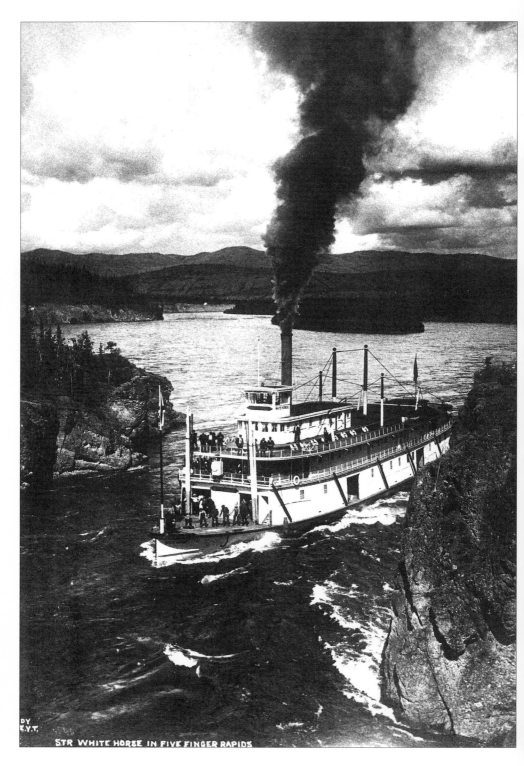

STR WHITE HORSE IN FIVE FINGER RAPIDS

A TRADE NETWORK

The White Pass and Yukon Route Railway established a modern trade network throughout the Yukon River watershed and beyond. This network displaced the business of traders such as the Hudson's Bay Company which had established posts throughout the region. The network also held great implications for northern native peoples who experienced a wide range of costs and benefits from this trade.

The railway brought goods and services never before available in the north. Its activities also spurred the creation of mines outside the Dawson region. These mines were not concerned solely with gold, and minerals such as lead and zinc were soon being sought. Company mining towns like Faro, Keno and Elsa were founded. Whitehorse and Skagway became service centers for these enterprises.

The spirit of adventure which had founded the White Pass and Yukon Route Railway continued in other endeavors. The company started containerized shipping, a practice which spread throughout the world. The company was the first to try loading large steel containers with cargo. These containers were loaded into ships and sent to Skagway. From Skagway huge derricks would lift these containers directly onto flatbed trains for shipping to Whitehorse. Eventually these containers would even be refrigerated, lessening food wastage and further expanding the range of goods that could be shipped.

The White Pass and Yukon Route Railway forever changed the face of this region of the north. Michael Heney's dream of a link between Skagway and Whitehorse ensured the prosperity of both these communities. The impact of the railway could be felt throughout Alaska, the Yukon and Northern British Columbia. The north would never be the same.

Sternwheelers loaded their holds full of supplies and traveled the entire length of the Yukon River. This trade provided goods and supplies throughout a broad region and collapsed traditional trade networks.

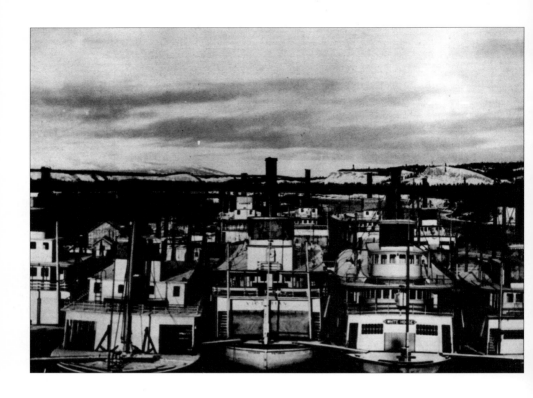

It was nearly five when several who were on the lookout for the first sight of steamboats saw a puff of smoke arising far up the bend beyond Klondike City. The cry of "Steamboat" was raised and the ubiquitous street gamins took it up and half the houses of the city emptied themselves, everyone rushing down to the waterfront to greet the craft so welcome. Seemingly within five minutes every dock was black with people and as the first boat appeared and tooted a merry good evening there was a yelling and cheering loud enough to awaken the dead.
The Klondike Nugget, May 1902

Above: The British Yukon Navigation Co. fleet, which was owned by the White Pass and Yukon Route Corporation, dry-docked for the winter at the shipyards in Whitehorse. 1901.

Opposite Top: The sternwheeler "White Horse" laden with passengers leaving Dawson. The "White Horse" was owned by the British Yukon Navigation Co. July 1901.

Opposite Bottom: The "Canadian," "Columbian" and "Victorian" at Dawson. A large crowd has gathered on decks and dock. 1899.

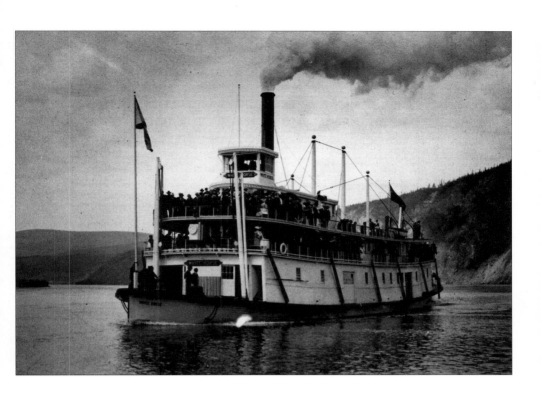

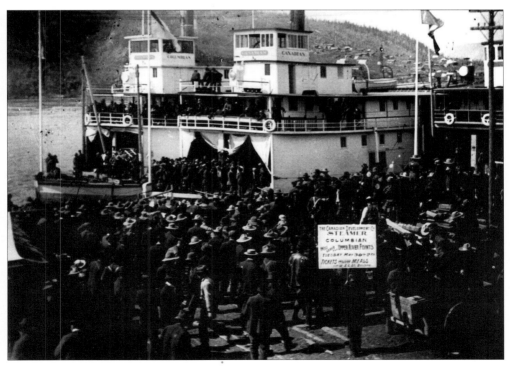

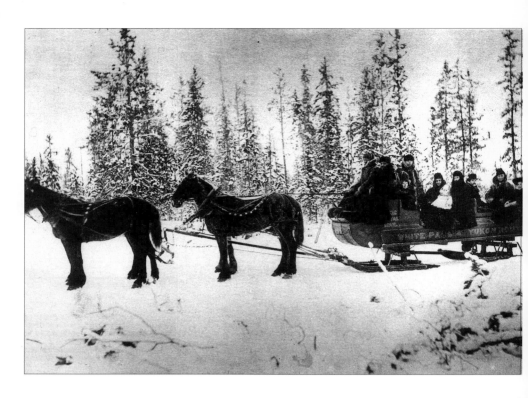

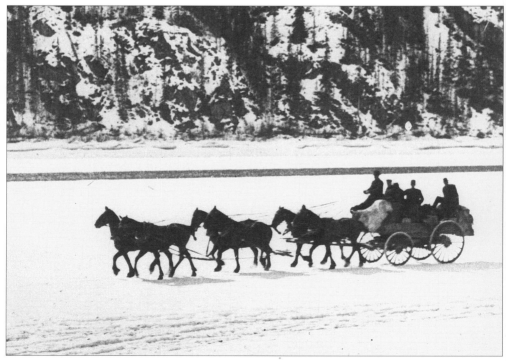

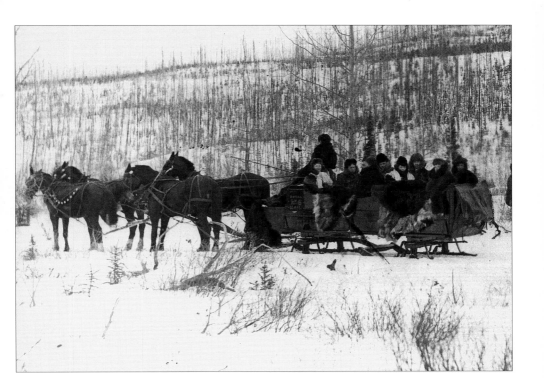

Above and Opposite: Horse-drawn sleighs in winter and horse-drawn coaches in the fall and spring traveled the 330 miles between Whitehorse and Dawson. Road houses were scattered every 22 miles and provided simple meals and accommodation. The journey took about five days and provided an important link between communities.

Drawn by four splendid horses, this open sleigh is a very comfortable affair, being upholstered and roomy with plenty of good fur robes and provided with foot warmers....Amid handshaking, good wishes and the hearty cheers of the bystanders, our jolly coachman cracks his long whip and off we start swiftly and silently over the pure white snow.
Selina Howard, 1910

Photograph Credits

Alaska State Library,
Harrie C. Barley
Collection
56 (PCA 126-25).

Alaska State Library,
Railroads in Alaska and
Yukon 1897-1950
Collection
26 and 27 (PCA 275-12-
76).

Alaska State Library,
Winter and Pond
Collection
66 and 67 top (PCA 87-
2961).
66 and 67 bottom (PCA 87-
2963).
88 bottom (PCA 126-23).

Yukon Archives
82.

Yukon Archives, H.C.
Barley Collection
6, 14, 16, 18 top, 19, 20, 23
top, 23 bottom, 24, 25, 28,
29 bottom, 30 top, 31, 32,
33, 34 top, 34 bottom, 35,
36, 40, 44 top, 44 bottom,
50 top, 54, 57, 58, 59 top,
59 bottom, 60, 62, 63, 64
top, 64 bottom, 68, 69 top,
69 bottom, 71, 74, 75
bottom, 76 and 77, 79
bottom, 80 top, 80 bottom,
89, 91 top, 92, 93 top, 93
bottom, 94 top, 94 bottom,
95, 96, 99 bottom, 102,
111, 112.

Yukon Archives, Martha
Louise Black Collection
38 top, 65, 99 top.

Yukon Archives, British
Columbia Archives
79 top.

Yukon Archives, Dennett/
Telfer Collection
72, 98.

Yukon Archives, E.A.
Hegg Collection
30 bottom, 37, 38 bottom,
41, 42, 43, 46 top, 48, 52,
53 top, 73, 81, 84, 100, 101
top, 101 bottom.

Yukon Archives,
J. Hunston Collection
103.

Yukon Archives, MacBride
Museum Collection
9, 13 bottom, 47, 50
bottom, 51, 104, 108 top,
109.

Yukon Archives, National
Archives of Canada
Collection
107 bottom.

Yukon Archives,
McLennan Collection
12.

Yukon Archives,
Scharschmidt Collection
106.

Yukon Archives,
Schellenger Collection
108 bottom.

Yukon Archives, Laurie P.
Todd Collection
75 top.

Yukon Archives,
University of Washington
Collection
8, 39.

Yukon Archives, Vancouver
Public Library Collection
46, 70 top, 70 bottom, 78,
107 top.

Yukon Archives, Vogee
Collection
11, 90.

Yukon Archives, Winter
and Pond Collecton
4, 7 top, 7 bottom.

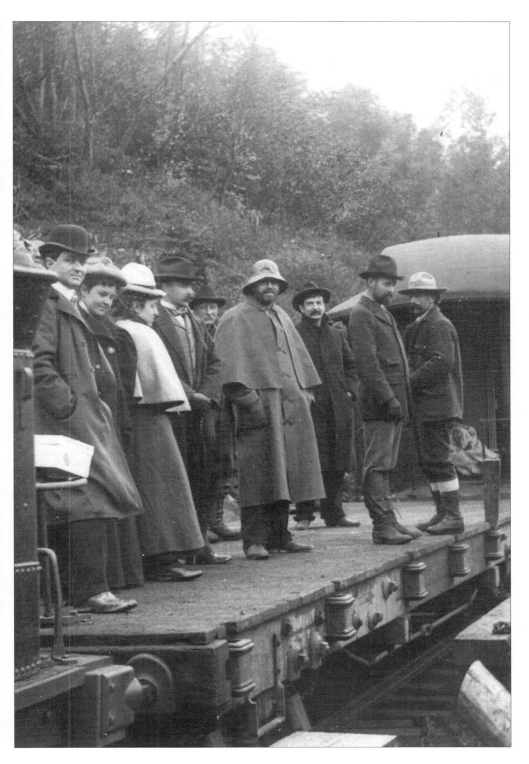

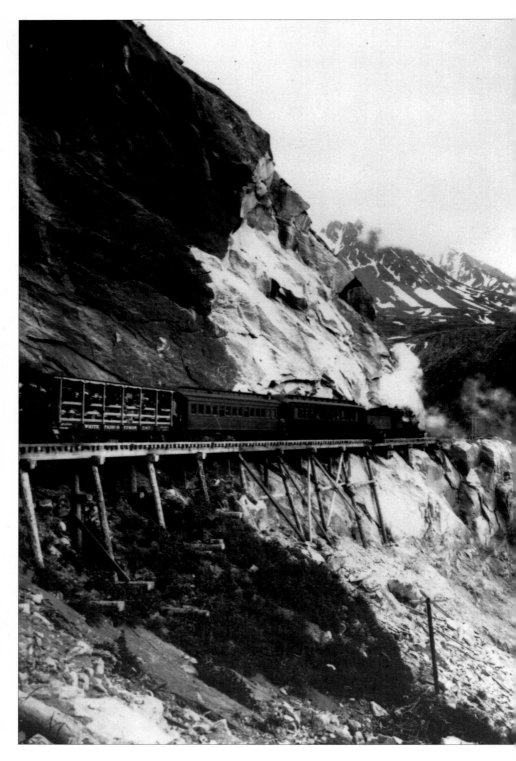